IMAGES
of America

# MILWAUKEE'S
# LIVE THEATER

Dear Camille,

I hope you enjoy our

fabulous local theater history!

Best wishes,

Jonathan

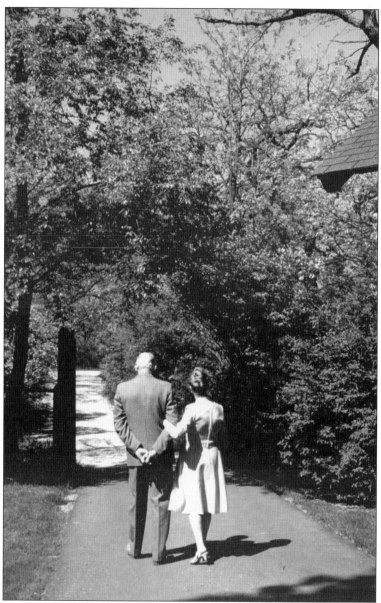

Alfred Lunt and Lynn Fontanne are seen strolling the grounds of their country estate, tucked away in the sleepy rural outpost of Genesee Depot just west of Milwaukee. Lunt and Fontanne's summer resting spot, Ten Chimneys, was a plot of land with cozy real estate in the unspoiled beauty of the quaint Wisconsin countryside where the two actors could rejuvenate their spirits and practice gracious living with friends like Noel Coward, Helen Hayes, and Alexander Woollcott. Their commitment to "real living" is a cherished legacy that all Milwaukee theater artists recall and strive to emulate. (Photograph by James Auer, courtesy of Ten Chimneys Foundation.)

*On the cover*: These actors are having a great time making plays in the Cabot Theater of the Broadway Theater Center. Milwaukee Chamber Theatre believed the actors in their production of *School for Scandal* looked so much like they were loving theater that they used this image to promote their 1994–1995 performance season. (Courtesy of Milwaukee Chamber Theatre.)

IMAGES
*of America*

# MILWAUKEE'S
# LIVE THEATER

Jonathan West

ARCADIA
PUBLISHING

Published by Arcadia Publishing
Charleston SC, Chicago IL, Portsmouth NH, San Francisco CA

Printed in the United States of America

Library of Congress Catalog Card Number: 2008940185

For all general information contact Arcadia Publishing at:
Telephone 843-853-2070
Fax 843-853-0044
E-mail sales@arcadiapublishing.com
For customer service and orders:
Toll-Free 1-888-313-2665

Visit us on the Internet at www.arcadiapublishing.com

*My mom says my name would look good on a book. Maybe she's right, but Judith West looks even better in a dedication. Thanks, Mom.*

# CONTENTS

# ACKNOWLEDGMENTS

Perhaps the most difficult aspect of a project like this is finding a suitable way to thank all the individuals who helped make my work easier. I thought I knew Milwaukee theater before I wrote this book. That claim was woefully naive. Many old and new friends helped me to see fully that the Milwaukee theater community has unending heart, impeccable sharing skills, and is full of people who possess a breathtaking knowledge of their craft. Oh, yeah, they also love to laugh—a lot.

Big thanks must go out to Konrad Kuchenbach and John Holland, patrons extraordinaire, who set me off on paths I had never even considered. I owe Dale Gutzman a huge debt of gratitude for superb tales and photograph memories of his "never-say-die" history. Sean Malone at Ten Chimneys will always be a friend, and he proves with his help on this project that he is a very good one.

The staffs of the many theater companies that participated in this project are already overburdened, so I am humbled that they returned all my calls. In particular I must acknowledge Kristin Godfrey, Cindy Moran, Cara McMullin, Elizabeth Kumrow, Sarah Hwang, Denise Shallitz, and Matt Kemple. The many Milwaukee theater champions who work in the trenches every day are to be applauded for their various contributions to my research.

Without the help of Ellen Engseth at University of Wisconsin-Milwaukee Archives, Matt Blessing at Marquette University Archives, and Sara Shutkin at Alverno College Archives, this history would be full of unnecessary holes. Thanks to Tim Kratesch and Sue Godfrey for sharing the extraordinary history of Melody Top. I am grateful to Laura Purdy for making it possible for new generations of theater fans to enjoy Walt Sheffer's stunning images of Fr. John Walsh's work.

Time was on my side because Mary "Jenny" Poppins filled in so many gaps with love and laughs. Finally, no work is possible without Paula. In fact, I would argue that no day is possible without her. She is that good at reminding me that I am a pretty lucky guy.

# INTRODUCTION

Time was when you asked someone to talk about Milwaukee's finest cultural assets, the answer might be, "They got great beer and brats there, right?" But beer and sausage have a shelf life, and it is unfair to think of Milwaukee and culture in those terms alone. All Milwaukee men, women, and children can thank their Germanic forefathers for the undeniably good brew and bratwurst, but that is a shortsighted tip of the hat. The story of Milwaukee and culture does not end at a frosty mug and an empty plate stained with mustard and relish. Opinions may vary on Milwaukee's finest cultural assets, but at the heart of that discussion there is one thing that no one will debate. Milwaukee is a world-class theater city.

This may be the greatest cultural secret in the United States today. It is no surprise that "the Milwaukee theater way" is something that folks outside the city do not understand. The Milwaukee theater community might not have promoted its reputation as a place where great theater happens the way that a city like its southern neighbor Chicago has, but there is a reason for that. Milwaukee theater artists have been too busy doing great productions of classic and new dramatic works to think about *New York Times* spreads. The Milwaukee theater community has been too busy building performance spaces for captive audiences to think about Broadway transfers of hit shows. The people behind making Milwaukee theater tick have been too busy raising families, paying taxes, cutting their lawns, and being good friends and neighbors to worry about becoming big-time Hollywood stars. Milwaukee theater is not about promotion, it is about product.

Milwaukee theater and Milwaukee-made Harley Davidson motorcycles share a lot of hometown qualities. Just like those legendary hogs, Milwaukee theater is ready for a long ride and fully equipped to weather the bumps along the road. Milwaukee theater also makes lots of noise, and in the contest to be heard above the din of daily life, Harley had better think about turning up the volume to keep up with the roar of the local theater scene.

Milwaukee has been a training ground for many artists who cut their teeth, learning their craft from legends like Fr. John Walsh at Marquette University, Robert Pitman at Alverno College, Sanford Robbins at the Professional Theater Training Program that was a part of University of Wisconsin-Milwaukee, and countless unsung heroes and heroines who brought generations of community theater actors through their ranks. Young actors and actresses apprenticed at the Fred Miller Theatre, and the sweat labor of eager up-and-comers kept places like the Melody Top alive in the roughest of times. Many Milwaukee producers have looked the other way when it came to following the letter of the law, but Milwaukee audiences easily forgave a tendency toward breaking rules because it resulted in some spectacular performances.

But that is not really any different of a story than any other town or city in the United States, right? Good cities want good things to do, and by sheer pluck and determination, theaters crop up in even the most out-of-the-way burg in the country. The story of Milwaukee theater is different because it is a story about a city too modest to tell the world it has one of the country's deepest theatrical talent pools. The Milwaukee theater story is one of push and pull. It is a story of groups like the German Theater Company and the Perhift Players playing to the needs of their German and Jewish audiences, while other producers set out to form professional groups of actors who would make a commitment to living and working in Milwaukee. It is a story of appreciating the past while looking to the future. It is the story of a city being at the heart of the regional theater movement and not even realizing it because it was so busy producing plays.

Milwaukee has always been an important "silent partner" in the evolution of the regional theater movement in this country. When theatrical visionaries in the 1940s and 1950s decided that New York City was not the center of the theater universe and that theaters belonged in communities throughout the United States, Milwaukee became one of the first metropolitan areas in the Midwest to establish a theatrical tradition as part of its civic personality. Before the 1950s, theater in Milwaukee had meant some semiprofessional and community theaters, a once thriving German theater scene, a respected Jewish theater ensemble, and a cultural landscape dotted with touring plays by the leading performers of the day. Thinking beyond that rich but loosely organized idea of what the idea of theater could mean for Milwaukee, a local group of movers and shakers decided in the early 1950s that a professional theater company in residence in Milwaukee was not just a desire but a necessity. Drama, Inc., was formed from that spark, and a huge firestorm of big, small, radical, homey, funny, heart-wrenching, and soul-stirring theatrical movements would follow.

Milwaukee audiences see world-class productions of drama and comedy on an almost nightly basis, and because of that Milwaukee firefighters, plumbers, waitresses, politicians, and coeds are often able to talk more in depth about the latest hit show they have seen than the Milwaukee Brewers' box scores. This is to say that Milwaukee theater is not just for old money, society types; it is theater for all people. Whether it is performed in the state-of-the-art Quadracci Powerhouse Theater that is the premier stage for the Milwaukee Repertory Theater or it is presented in Darling Hall, a squatter's paradise of mismatched lighting equipment and torn curtains, Milwaukee theater is a movement of theater that embraces the idea of taking a chance. It is a movement that welcomes new audiences and embraces incoming members of the creative class with warmth and encouragement. Milwaukee theater is theater for the people, by the people, and about the people.

Milwaukee people are the reason Milwaukee theater keeps going. Those Milwaukee people are not just the actors and actresses that audiences see onstage. Milwaukee theater continues to exist because a couple of men sharing a quaint home south of downtown Milwaukee have an inventory of playbills from every performance they have seen over a 50-year love affair with Milwaukee theater. Milwaukee theater is vibrant because a unified arts fund makes regular folk remember to throw a few sheckles to groups seeking to produce more plays. Milwaukee theater will not die because when one generation of theater artists gets too burned out to keep making plays, there is always a new group of enthusiastic young Turks waiting in the wings ready to carry the torch into the future.

In documenting the history of Milwaukee theater while it continues to move forward at lightning speed, it is necessary to talk in broad strokes. Some ensembles have closed their doors, while others have endured for decades. Milwaukee theater is not like the theater you will see in New York City. It is not like the theater you will see in London, or Chicago. It is a secret blend of good people, progressive thought, and community support.

And, of course, the best cap to an evening of theater in Milwaukee is a sizzling hot brat washed down with a frosty cold beer.

# One

# THE LEGACY

The breadth and scope of Milwaukee's live theater offerings did not materialize overnight. In 1842, the population of what was then the village of Milwaukee was just over 2,000. A city charter would not be adopted until 1846 when Solomon Juneau would become Milwaukee's first mayor. Despite this lack of an organized civic structure, the early Milwaukee settlers were eager to be entertained, and that meant they wanted to see a play.

The first record of theater in Milwaukee is in 1842 when the Detroit and Chicago Company offered a touring production of *The Merchant of Venice*. By 1843, a modest group of players broke off from the Detroit and Chicago Company and staked their claim as the first organized group of theater artists to produce plays in Milwaukee. Their company was called the Rice Stock Company after their producer and benefactor, John B. Rice, the wealthy Chicago theater owner who would later become mayor of the Windy City. Rice Stock Company first performed in a courtroom of Military Hall on the site where the current Milwaukee City Hall stands. Their work was of dubious quality, but audiences hungry for any kind of theater lapped up plays like *Dumb Belles* and *The Drunkard*.

By 1849, the German Dramatic Society was formed, playing to a large German population eager for dramatic entertainment from the motherland. "Papa" Henry Kurz became the German language theater troupe's impresario, renaming the company the Kurz German Stock Company. Kurz's stewardship of this troupe laid the foundation for the long-running Stadt Theater Company, also known as the German Stock Company. The German Stock Company continued performances until 1935, when administrators finally dissolved the company, claiming there was no longer an audience for their work.

From the early 1900s through the 1940s, Milwaukee theater audiences also enjoyed touring productions of classics and popular plays of the day by legends of the theater world like Helen Hayes, Alfred Lunt, and Lynn Fontanne. Audiences took in these star vehicles at theater palaces like the Pabst and the Davidson before the touring circuit became too expensive for producers to support.

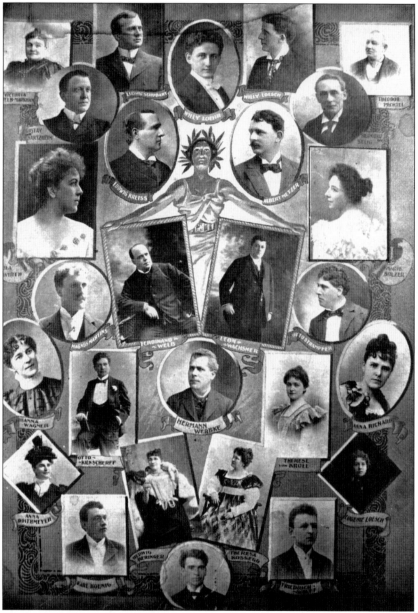

The German Stock Company was the leading German-language theater in Milwaukee during the late 1800s and early 1900s, but it was far from the only presenter of German-language theater for Milwaukee audiences. This undated photograph of the German Stock Company's leading actors is a testament to the fact that German theaters were able to thrive in Milwaukee for over 50 years. "Papa" Henry Kurz built the glittering Stadt Theater in 1868 as a temple for his company, but by 1895 the Stadt had ceased to exist as a performance venue. Hard financial times hit the German-language theater in Milwaukee as anti-German sentiment filtered into the public consciousness during World War I. By the mid-1930s, after concessions such as performing works in English, the German theater movement could no longer support itself and became a part of Milwaukee's theater history. (Courtesy of University of Wisconsin-Milwaukee Libraries, Archives Department.)

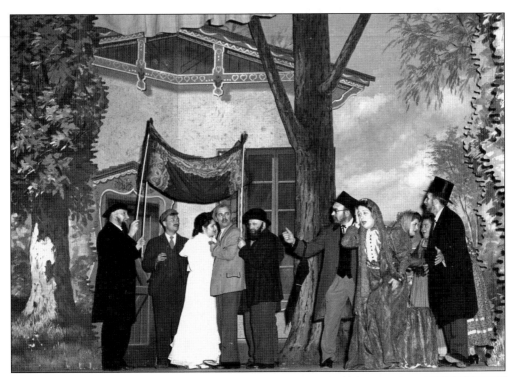

When a group of young Jewish immigrants came together at the Abraham Lincoln house in 1921, their intention was not to start a theater. They first called themselves the Yiddish Literary and Dramatic Society, but when members started producing actual short plays, it made sense to change the name of the troupe to the Yiddish Drama League. As World War II drew to a close, Milwaukee's Yiddish theater troupe settled on the name it would use well into the 1970s. The Perhift Players were named after Yiddish playwright Peretz Hirschbein, and their agenda was quite simply to produce Yiddish plays for the Milwaukee Jewish community. Perhift performed works that dealt with the old country like *It's Hard to Be a Jew* (above) and plays that dabbled with new country struggles like *Uncle Moses* (at right). (Courtesy of Jewish Museum Milwaukee.)

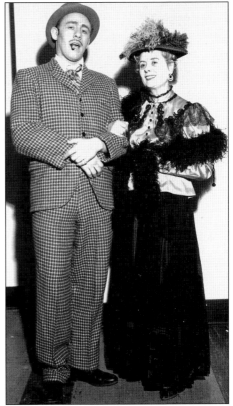

## PABST THEATER
**MARGARET RICE, Manager**
**Tuesday Evening, April 30, 1935**

The Theatre Guild, Inc.

Presents

# Mary of Scotland

A Play by
MAXWELL ANDERSON

WITH

### HELEN HAYES
### IAN KEITH
### PAULINE FREDERICK

The Production Directed by Theresa Helburn
Settings and Costumes Designed by Robert Edmond Jones

### Special Performance

SUNDAY, MAY 12, 1935

## NAZIMOVA - - - in "GHOSTS"

Because of the extraordinary interest shown at the Pabst Theatre box office in the
appearance of Nazimova and her company of Theatre Guild artists, it has been
necessary to add another performance to her Milwaukee schedule.

Robert Henderson has persuaded Nazimova to appear, **for one performance only,**
on Sunday evening, May 12, at the Pabst Theatre, as Mrs. Alving in Henrik Ibsen's
masterpiece, "Ghosts;" with Romney Brent as her son Oswald, and McKay Morris,
Lionel Pape and Patricia Calvert in her supporting company.

Nazimova was the first star to popularize Ibsen in America; her interpretations
of the great Ibsen roles are regarded by critics as incomparable. For the first time—
at the climax of her career—she comes as one of his most remarkable characters—
Mrs. Alving, in "Ghosts." Not included in subscription. Prices: $1.50—$1.00—75c—50c

---

The Pabst Theater has a long history as a place where Milwaukee audiences enjoy plays. Built as a replacement to the Stadt Theater in 1895, the Pabst was the subsequent home of the German Stock Company. As these theater playbills from 1935 show, the Pabst showcased touring productions featuring the biggest stars of the American theater. Helen Hayes performed *Mary of Scotland* to great acclaim, and the Theatre Guild's 1935 Drama Festival featured stars like Irene Bordoni and Walter Slezak performing new work by Noel Coward. Imagine the thrill of the first-nighters taking in a breathtaking performance by the legendary Hayes or laughing at a droll new lyric from the master wit of Coward. These gold standard touring shows helped Milwaukee audiences refine their already discerning tastes. (Courtesy of Milwaukee Repertory Theater.)

## PABST THEATER
**MARGARET RICE, Manager**
**Thursday Evening, May 16, 1935**

### The 1935 Drama Festival

ROBERT HENDERSON, Director
Stewart Chaney, Art Director

| | |
|---|---|
| **"ODE TO LIBERTY"**<br>May 16-17-18 | Walter Slezak and Ilka Chase in Mr. Slezak's gay success this season in New York. |
| **"UP TO THE STARS"**<br>Sunday, May 19-25 | Irene Bordoni, Walter Slezak, Ilka Chase, The Rocky Twins, in this Musical Revue with songs and sketches by NOEL COWARD, never presented in America before. |
| **"THE BISHOP MISBEHAVES"**<br>May 26-June 1 | Tom Powers, Estelle Winwood, Effie Shannon in Frederick Jackson's current New York hit. |

### Subscription Books Available for Four Festival Plays

**BY SUBSCRIBING YOU SAVE!**

One Pair of Tickets for 3 Plays — Prices: $6.00, $5.10 and $3.90.

INQUIRE AT BOX OFFICE

### Irene Bordoni — Noel Coward

Someone recently said that the cast of stars appearing in the Festival musical revue, "Up to the Stars," with words and music by Noel Coward, never presented in America before, could not possibly be presented in New York; for their New York salaries would be prohibitive.

Such a list it is! The one and only Irene Bordoni, Walter Slezak, Ilka Chase, the famous Rocky Twins from Paris, Mlle. Nina Tarasova, Imogene Coca, Jessie Royce Landis, the dancers Felicia Sorel and Demetrios Vilan—to mention only the featured stars. And Noel Coward's

enchanting music and lyrics from his recent London success, "Words and Music," receiving their American premiere.

Miss Bordoni alone would be star enough for a New York revue. In "As You Were," "The French Doll," "Little Miss Bluebeard," and the brilliant "Paris" with the Cole Porter hit tune, "Let's Do It." Pictures, radio, too, have made Miss Bordoni famous. She is unique; in her smartness, her gaiety, her chic verve and style. She is one of many who will make "Up to the Stars" memorable.

Lowbrow humor from the likes of Jackie Gleason (at right) and William Shakespeare's highbrow art (below) were presented in harmony at Milwaukee's Davidson Theater. The theater opened in 1890 and was the most successful operating show place in Milwaukee for decades. When the Pabst Theater closed for repairs in 1928, the German Stock Company performed several plays at the Davidson. Touring shows were the Davidson's bread and butter until the theater was demolished in 1954. Changing times and the need for more parking spaces from the nearby Boston Store were the leading causes of the demise of the Davidson. (Courtesy of Milwaukee Repertory Theater.)

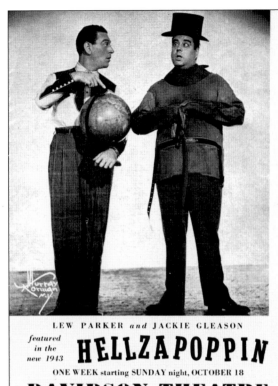

LEW PARKER *and* JACKIE GLEASON

*featured in the new 1943* **HELLZAPOPPIN**

ONE WEEK starting SUNDAY night, OCTOBER 18

# DAVIDSON THEATRE
Milwaukee, Wisconsin

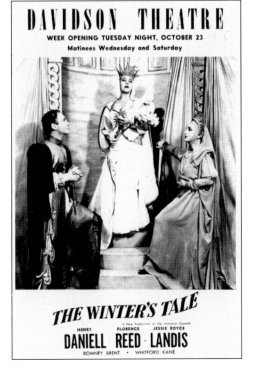

# DAVIDSON THEATRE
**WEEK OPENING TUESDAY NIGHT, OCTOBER 23**
Matinees Wednesday and Saturday

*THE WINTER'S TALE*

A New Production of the Immortal Comedy

HENRY FLORENCE JESSIE ROYCE
**DANIELL · REED · LANDIS**
ROMNEY BRENT · WHITFORD KANE

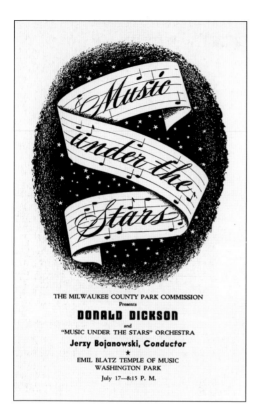

In the city where many people believed beer flowed from the water taps, it came as no surprise to see performance venues named after brewing companies. Blatz Brewing Company's Emil Blatz put up money to build Blatz Temple in Washington Park in 1938. Music under the Stars offered concerts and fully staged musical theater productions there for Milwaukee audiences for 55 years until closing in 1992. (Courtesy of Milwaukee Repertory Theater.)

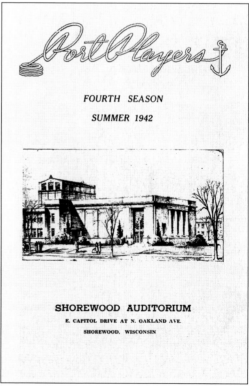

FOURTH SEASON

SUMMER 1942

**SHOREWOOD AUDITORIUM**

E. CAPITOL DRIVE AT N. OAKLAND AVE.

SHOREWOOD, WISCONSIN

The Port Players organized as a stock theater troupe in Port Washington in 1939. Finding it hard to attract an audience because of wartime gas rationing, they brought their performances closer to a theatergoing population. The Shorewood High School Auditorium was their home base until they were asked to vacate when town officials balked at the content of some of their material. (Courtesy of Milwaukee Repertory Theater.)

*Idiot's Delight* may have been the name of the 1936 Pulitzer Prize winner that toured to Milwaukee with Alfred Lunt and Lynn Fontanne, but it did not take an idiot to be delighted by the stars of the show. The Lunts toured extensively, but summers were meant for play. That meant heading home to a little town just west of Milwaukee called Genesee Depot. (Courtesy of Ten Chimneys Foundation.)

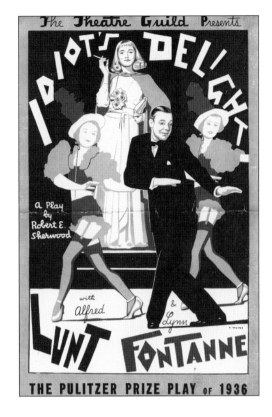

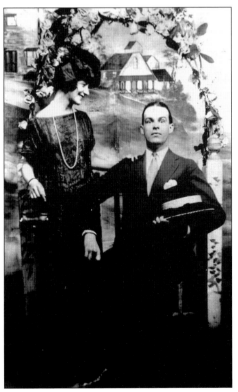

This whimsical wedding pose is rare Lunt and Fontanne. They both seem to be hamming for the camera, but there is no doubt they are serious about their love of life and each other. Lunt and Fontanne embodied a spirit of enthusiasm for the theater and the good life, and left an example that all Milwaukee theater artists hope to emulate. (Courtesy of Ten Chimneys Foundation.)

15

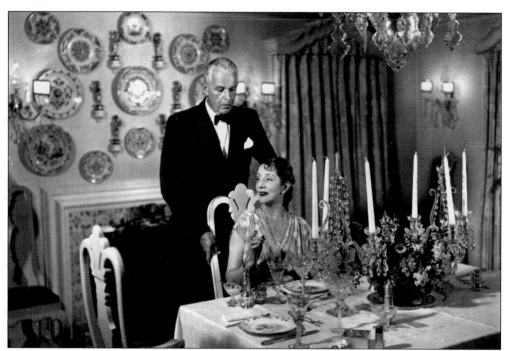

Whether they were dressing for a formal dinner or taking a dip in their charming outdoor pool, Alfred Lunt and Lynn Fontanne were the definition of élan and gracefulness. They could have lived high on the hog in New York, Paris, or London when they were not touring in any number of their hit plays, but they chose to retreat to the wooded estate appropriately named Ten Chimneys for the smokestacks that could be seen from the dirt road leading to their land. Their time at Ten Chimneys was full of honest respect and warmth for each other and their many friends. (Photographs by Warren O'Brien, part of the O'Brien family collection at the Wisconsin Historical Society; courtesy of Ten Chimneys Foundation.)

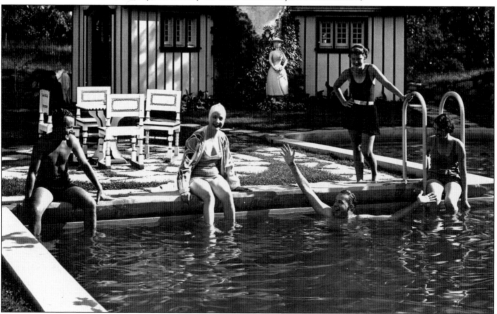

At Ten Chimneys, Lunt was in charge of manual labor and cooking while Fontanne tended to flowers and plants. Noel Coward (below, right) was the often-present "Lord of Mischief" at Ten Chimneys. Stories of Coward prancing around the grounds in his birthday suit and charming the many workers who helped Lunt tend to the estate were in abundance. This home away from home for the leading theater legends of their day offered artistic geniuses the chance to dream and create their next masterpieces. (Photographs by Warren O'Brien, part of the O'Brien family collection at the Wisconsin Historical Society; courtesy of Ten Chimneys Foundation.)

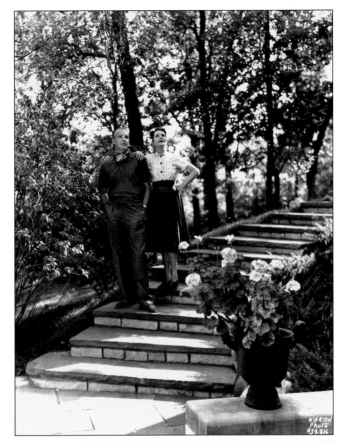

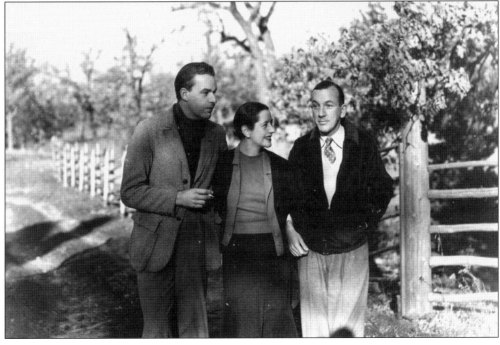

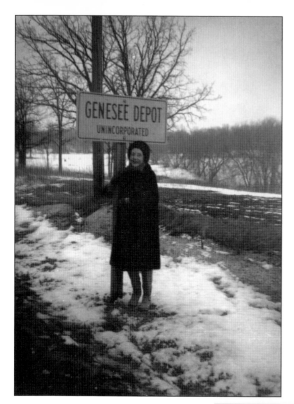

Lynn Fontanne clutches a sign marking her much-loved retreat. The gracious living that Alfred Lunt and Lynn Fontanne sought at Ten Chimneys is still on display for generations of theater fans to cherish at their lovingly restored home in Genesee Depot. The Lunt-Fontanne generous spirit inspires new generations of theater folk every day in Milwaukee and beyond. (Courtesy of Ten Chimneys Foundation.)

The Lunts' appearance in Friedrich Durrenmatt's *The Visit* was heralded as a landmark American theater experience. *The Visit* was one of their final tours in the 1960s before they retired permanently to Ten Chimneys. The legendary production they first performed on Broadway in 1958 landed at their "home theater," the Pabst. Most of their touring shows started or ended their run at the Pabst. (Courtesy of Ten Chimneys Foundation.)

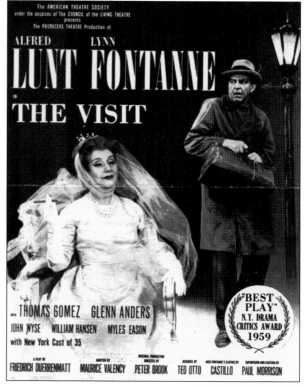

# *Two*

# THE CURTAIN RISES

Laura Sherry was not a woman who liked to rest. She raised a family, edited books, and helped establish the experimental theater movement in this country. She did not need to be an East or West Coaster to do all this. Sherry founded the Wisconsin Players in Milwaukee, leading her band of community players through a great run from 1899 to 1940. Their work was performed in a converted house on North Jefferson Street, and they dabbled in experimental theater ideas as well as the classics. Sherry's troupe of players did amazing things during their time performing for Milwaukee audiences, but there was one thing they could never fully claim to be: professional.

By 1953, Milwaukee was on the precipice of emerging as a professional theater mecca. Pointing to the success of regional theaters in Dallas, Philadelphia, and other American cities, a collective of Milwaukee community and business leaders organized to secure Milwaukee's reputation as a theater-loving city. The result of their efforts was Drama, Inc., a Milwaukee-based professional theater company.

Drama, Inc., was different from other theatrical start-ups in several ways. It was a nonprofit company, so fund-raising and education were important parts of its mission. The captain steering the ship of this organization also did not belong to an old boy network. The first president and managing director was a theater-savvy Milwaukee wife and mother named Mary John. Her background as former assistant to Broadway producers, advertising professional, and drama educator made her uniquely qualified to run Milwaukee's flagship company.

Mary John convinced a group of businessmen to raise the necessary funds to convert an ancient movie house into a 300-seat arena-style theater. Beer baron Fred Miller chaired the successful fund-raising drive. In a tragic event, Miller died in a plane crash just a month before he could see the fruits of his labor realized. In honor of Miller, the theater was called the Fred Miller Theatre, and it opened on January 25, 1954. This legendary company would go on to become the Milwaukee Repertory Theater, one of the country's most respected professional theater companies.

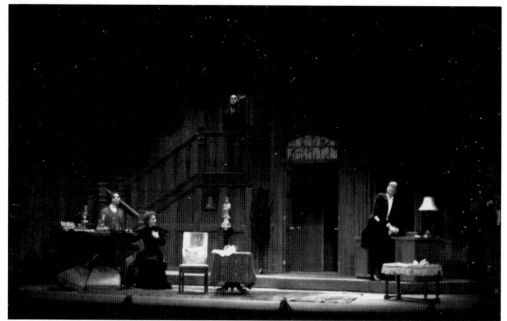

Lofty artistic ambitions guided the Milwaukee Players when they formed in 1924. Created under the auspices of the Milwaukee Department of Municipal Recreation of the Milwaukee Public School system, the Players had their work chosen by a "Better Play Committee." Shakespeare was the playwright of choice in the Players' early years, but the amateur troupe went on to perform comedies, dramas, and musicals through the 1990s. (Courtesy of Dale Gutzman.)

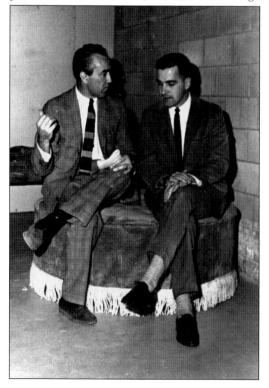

Alan Furlan (left) is seen here in a 1963 photograph giving some notes before a first public performance at the Sunset Playhouse Community Theater. Furlan was a Milwaukee area fixture as the artistic director of Sunset Playhouse for over 30 years. Furlan had been a touring actor in the 1950s, but ended up helping to train countless amateur theater artists for careers in the professional theater. (Courtesy of Sunset Playhouse.)

Furlan believed that Sunset Playhouse must be run with professional standards and practices. He was aided in part by Sunset's unique ownership of a well-conceived, high-functioning theater (above). Ownership of the space made it possible for artists working at the Sunset to avoid the challenges of performing in a gymnasium or multipurpose room faced by other community theaters focused on creating great work. Although Sunset Playhouse had the bricks of a building, the real mortar that has continued to hold the area's premier community theater together are the volunteers who commit endless hours to making theater. (Courtesy of Sunset Playhouse.)

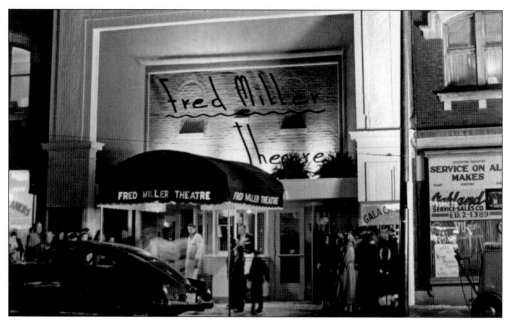

The Fred Miller Theatre is seen in all its brand-new splendor in this photograph from 1954. When it opened in a remodeled movie theater in January 1954, it was hailed as "the only professional winter arena" in the state and was believed to be one of only 11 regional theaters in the nation. (Courtesy of Wisconsin Historical Society.)

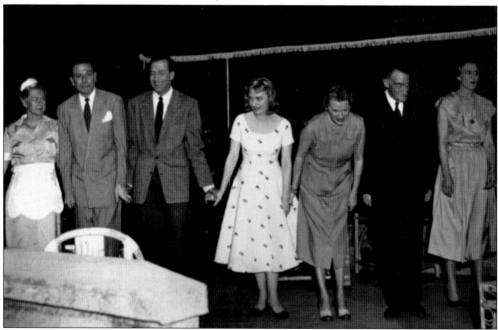

The Fred Miller Theatre's first production was a Broadway hit from 1948 making its debut in Milwaukee called *Sabrina Fair*. The cast included professional actors who had worked in stock theater around the country. The play was headlined by Hollywood and television star Jeffrey Lynn (third from left) and Milwaukee native Olga Bielinska (third from right). (Courtesy of Wisconsin Historical Society.)

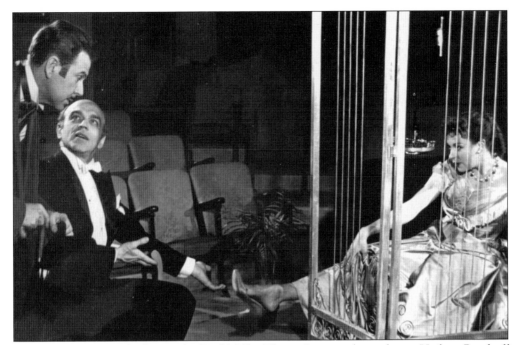

The star system was the key to the Fred Miller Theatre's original popularity. Herbert Berghoff (seated in chair) and Uta Hagen (woman behind bars) graced the Fred Miller's stage in *Cyprienne* during the 1954 season. Berghoff was a towering presence on stage and a legendary teacher. Hagen's talents were well known by audiences, and she would later go on to create the role of Martha in *Who's Afraid of Virginia Woolf?* (Courtesy of Wisconsin Historical Society.)

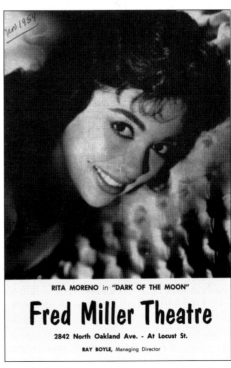

RITA MORENO in "DARK OF THE MOON"

# Fred Miller Theatre

2842 North Oakland Ave. - At Locust St.

RAY BOYLE, Managing Director

Rita Moreno (seen on the program for *Dark of the Moon*) and other stars captivated Milwaukee audiences in the Fred Miller's intimate 338-seat theater. Original managing director Mary John claimed that an undersupply of tickets would create a demand for them. Her notion would be tested again and again as the theater found its artistic way. (Courtesy of Milwaukee Repertory Theater.)

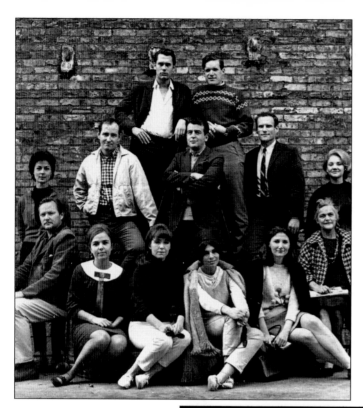

In 1963, Fred Miller Theatre became Milwaukee Repertory Theater. Tunc Yalman (center, in front of ladder), the theater's first artistic director, is flanked by his resident company of actors. Supporting a resident company of professional actors committed to work in Milwaukee was a legacy that followed Yalman through three succeeding artistic directorships. (Courtesy of Milwaukee Repertory Theater.)

Michael Fairman, Erika Slezak, and Charles Kimbrough were part of Tunc Yalman's early resident company. Their appearance here in Noel Coward's *Design for Living* was typical of the shift in programming that occurred when Fred Miller Theatre became Milwaukee Repertory Theater. A broader commitment to classics and contemporary plays was at the heart of that mission. (Courtesy of Milwaukee Repertory Theater.)

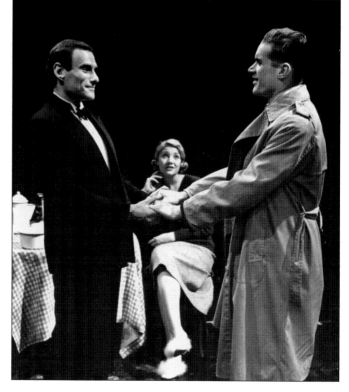

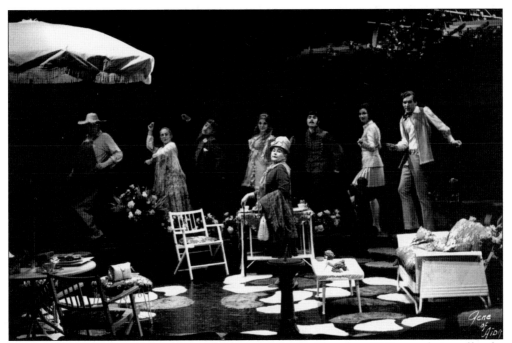

While audiences at Milwaukee Repertory Theater in the mid- to late 1960s were being offered a fairly traditional lineup of plays from the theatrical cannon, the productions were anything but staid. This 1967–1968 season production of *The Importance of Being Earnest* immediately brings to mind the reaction, "Groovy, man, groovy!" (Courtesy of Milwaukee Repertory Theater.)

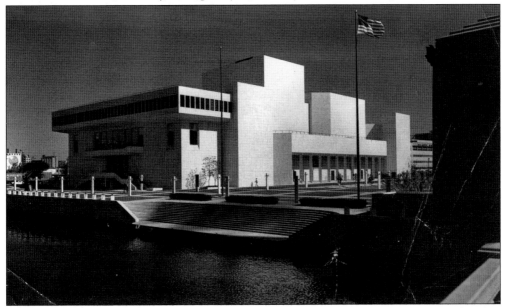

Milwaukee Repertory Theater had firmly established its place in the gold circle of Milwaukee cultural assets by the late 1960s. Sensing the need to foster even more growth and exploration and hindered by production limitations in the Fred Miller Theatre, Milwaukee Repertory Theater became one of the first resident companies at the Performing Arts Center in 1968. (Courtesy of Milwaukee Repertory Theater.)

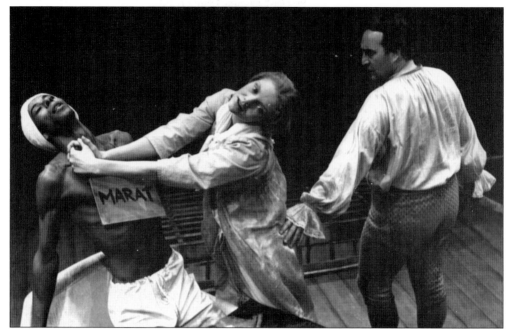

As Milwaukee Repertory Theater planned for its move downtown to the 504-seat Todd Wehr Theater, programming started to suggest a more adventurous agenda. *Marat Sade* (pictured above) was a harrowing play in one of Milwaukee Repertory Theater's last seasons at the Fred Miller Theatre on Oakland Avenue that let patrons know that the theater's move downtown would signal more than a new mailing address. New artistic director Nagle Jackson came in to lead Milwaukee Repertory Theater during most of the 1970s. He promoted an agenda of developing and championing new works like *The Prince of Peasantmania* (seen below with John Glover in the title role) for the Milwaukee Repertory Theater's growing audience. (Courtesy of Milwaukee Repertory Theater.)

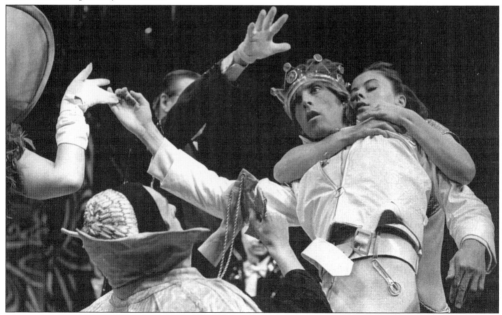

Members of the Milwaukee Repertory Theater acting company in the 1960s and 1970s would go on to become successful Broadway and television actors. Charles Kimbrough was a valuable member of the resident company in the 1960s and 1970s who would appear in the original cast of Stephen Sondheim's musical *Company* on Broadway. Young actors Judith Light (at right) and Jeffrey Tambor (below) were familiar faces for Milwaukee audiences in the 1970s. Light was Milwaukee Repertory Theater's ingenue, and Tambor was a popular utility player much beloved for his varied takes on the character roles he so often played. Both performers would go on to earn a national reputation as talented actors well known to television audiences. (Courtesy of Milwaukee Repertory Theater.)

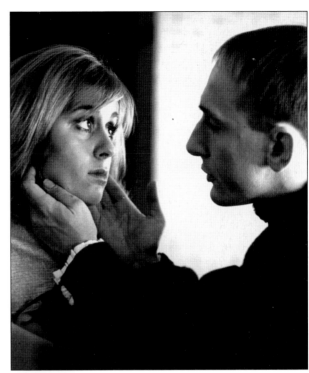

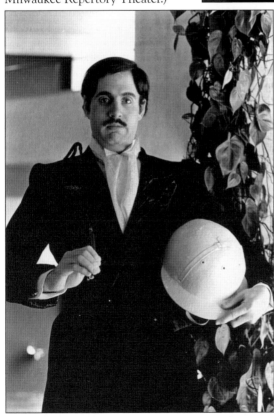

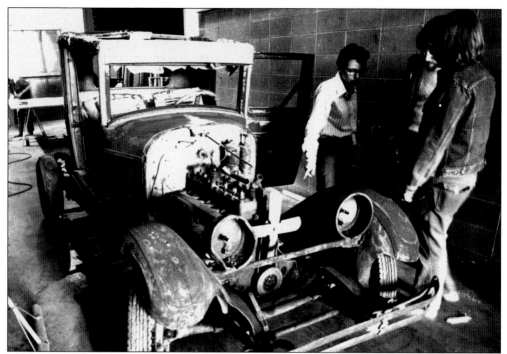

Milwaukee Repertory Theater introduced a new level of theatrical craftsmanship to Milwaukee audiences. Whether they were figuring out how to fit a car onstage (above) or making sure actors' costumes were not too snug (below), the artisans that became full-time staff members of Milwaukee Repertory Theater's production shops in the 1960s and 1970s had a huge effect on the local community's theatrical knowledge base. The corollary effect of Milwaukee Repertory Theater employing these types of professionals in full-year or seasonal contracts meant that talented artisans moonlighted for other smaller theaters, bringing their craftsman skills to every corner of Milwaukee theater. (Courtesy of Milwaukee Repertory Theater.)

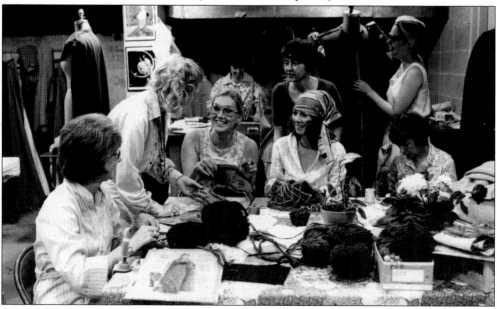

During Nagle Jackson's tenure as artistic director, Milwaukee Repertory Theater patrons could expect to see American classics like *Our Town* (at right) and edgy and smart new plays like *Joe Egg* (below). Jackson helped the Milwaukee Repertory Theater move into the big leagues of regional theater. He brought in new playwrights like Romulus Linney and Amlin Gray. He introduced actors in his first years as artistic director who committed to the city and performed with the company for over 30 years. Perhaps his single biggest contribution to Milwaukee Repertory Theater was conceiving of the theater's annual grand production of *A Christmas Carol* at the Pabst Theater. That show has become a huge part of Milwaukee Repertory Theater's identity over the years, as well as a holiday tradition for generations of theater fans. (Courtesy of Milwaukee Repertory Theater.)

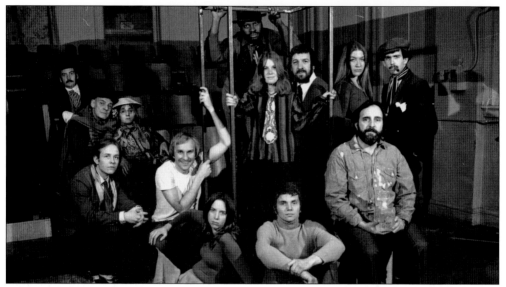

Milwaukee Repertory Theater needed to spread its wings in new artistic directions in the mid-1970s. To do so, it needed a small theater where it could take risks. This meant thinking outside the box, and outside downtown for an altogether new type of performance space. In 1974, Milwaukee Repertory Theater converted a bare-bones warehouse space just north of its regular home at the Performing Arts Center. The Court Street Theater was a place where members of the Milwaukee Repertory Theater acting company could do muscular acting, take risks, and showcase bold ideas for over 10 years. As the photographs suggest, the Court Street Theater was intended to promote a manner of theatergoing for Milwaukee audiences that was relaxed, casual, audacious, daring, and a little rough around the edges. (Courtesy of Milwaukee Repertory Theater.)

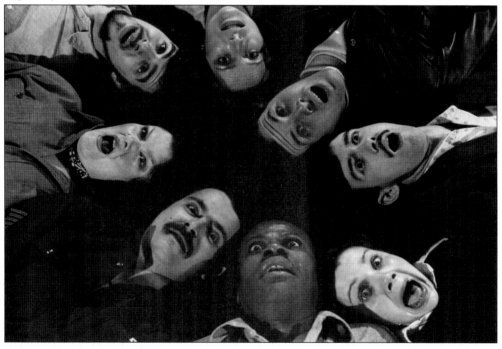

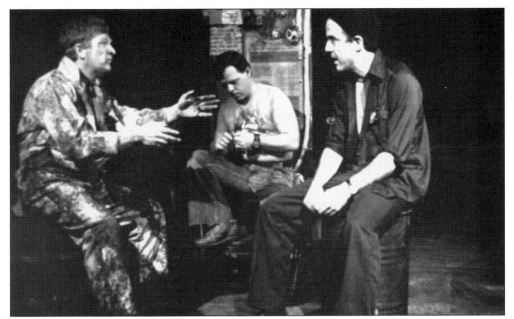

Talented playwrights premiered many new plays at Milwaukee Repertory Theater in the 1970s and 1980s. Master wordsmith David Mamet saw his play *Lakeboat* (above) performed by Paul Meacham, Eugene Anthony, and Larry Shue in 1980. Shue, who was also a member of the Milwaukee Repertory Theater's resident acting company, began his successful career as a playwright when encouraged by John Dillon, Nagle Jackson's successor as artistic director, to try his hand at putting something together for his fellow actors. Peter Ryboldt, Betty Horan, and Alan Brooks are seen below in a scene from Shue's popular 1983 hit *The Foreigner*. Shue's skyrocketing career as an actor and playwright was tragically cut short when he died in a commuter airline crash in 1985. (Courtesy of Wisconsin Historical Society.)

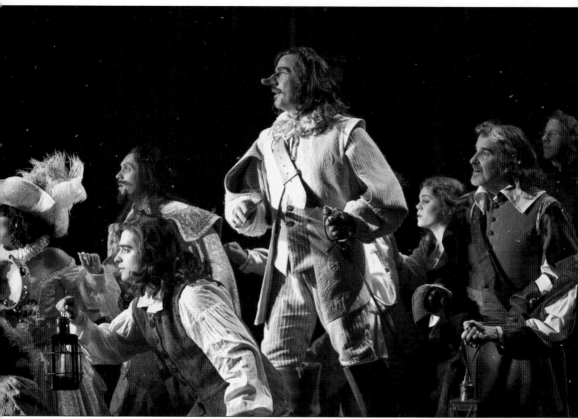

Joseph Hanreddy became artistic director of Milwaukee Repertory Theater in 1993. Long gone were the days of a star system. His predecessors as artistic director had made tremendous artistic strides. Managing directors Charles McCallum, who served from the Fred Miller days to 1974, and then Sara O'Connor, a visionary woman producer, shored up the company's stability. When Hanreddy stepped into the job of artistic leader of Wisconsin's biggest theater troupe he was able to dream big. He continued the tradition of maintaining a resident company of actors, something that continued to make Milwaukee Repertory Theater unique when compared with other American regional theaters. The benefits of supporting an A-list of in-house talent continues to amaze Milwaukee audiences as they did in Milwaukee Repertory Theater's 2007 production of *Cyrano*. (Photograph by Jay Westhauser, courtesy of Milwaukee Repertory Theater.)

Milwaukee Repertory Theater produces plays in a downtown theater complex that houses three performance spaces. The 720-seat Quadracci Powerhouse Theater is Milwaukee Repertory Theater's main stage. That state-of-the-art thrust theater space was constructed from a vacated power plant on the Milwaukee River next door to the Pabst Theater. Complementary spaces at the Stiemke Theater, where this 2007 production of *The Nerd* (above) played, and the Stackner Cabaret, where theatergoers dined, drank, and toe tapped to the musical revue *Hula Hoop Sha-Boop* (below), make it possible for Milwaukee Repertory Theater to produce almost 20 full productions every season. (Photographs by Jay Westhauser, courtesy of Milwaukee Repertory Theater.)

The impact that Milwaukee Repertory Theater has had on the whole of the Milwaukee theater scene is immeasurable. Every start-up, every mom-and-pop organization, and every mid-sized theater in Milwaukee in some way exists because of the staying power of Milwaukee Repertory Theater. Some artists have formed their own troupes hoping to offer more radical theater experiences to local audiences than Milwaukee Repertory Theater is able to offer. Others have organized their own collectives after apprenticing with the company and feeling inspired to try to emulate the work being done at "the big house." The original folks behind Drama, Inc., and the Fred Miller Theatre did not realize what they were actually doing when they produced that first play, *Sabrina Fair*. They inspired a community to discover theater in ways they had never imagined before. (Courtesy of J. T. West.)

# *Three*

# PLAYS THAT SING

Clair Richardson was a public relations man working in post–World War II Milwaukee who had big clients with deep pockets. He sported finely tailored suits, enjoyed the freedom of expense accounts, and reveled in all the trappings of a successful advertising man. Richardson also made a name for himself in Milwaukee as an arts enthusiast who had been involved in the start-up for groups like the Fred Miller Theatre and Milwaukee Symphony Orchestra.

In 1959, Richardson and his chess buddy Sprague Vonier, station manager of WTMJ-TV, rented an empty office building next to Richardson's Jackson Avenue public relations firm with the intention of turning it into a club for their hobby. The men never set up a board, however, because Vonier bit at Richardson's wily proposition to "have some fun" in the space and produce an evening of Gilbert and Sullivan. The success of their scrambled-together production signaled the end of high times for Richardson. Clair Richardson would soon become a legendary Milwaukee Bohemian whose panache as a pitchman made the Skylight Comic Opera Theatre the place to be for the downtown set.

Richardson's eclectic and engaging Skylight Comic Opera Theatre was not the only musical game in town for Milwaukee music theater fans during the 1960s. On the north side of Milwaukee, a big top tent theater called the Melody Top looked like "the greatest show on earth" when it was erected in 1964. Milwaukee's well-connected social and political forces soon learned to love the elbow-rubbing experience of watching star vehicle musical theater productions in a circuslike atmosphere.

The Skylight Comic Opera Theatre and the Melody Top might have only been 20 miles or so apart from each other on a Milwaukee street map, but in terms of the type of work they did, the two troupes were worlds apart. Richardson and his dedicated audiences were looking for something off the beaten path, while Melody Top was committed to presenting fully produced Broadway-quality entertainment for the masses. Both groups did, however, send legions of Milwaukee patrons out of the theater with a song in their heart.

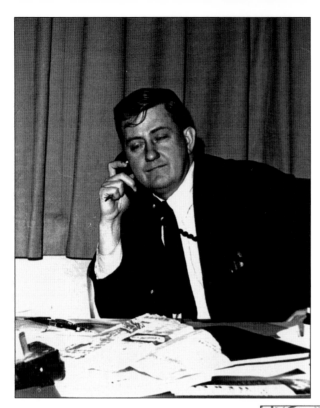

It is generally assumed by those who happen upon this picture of Clair Richardson that he is drunk from a devilishly long day of wining, dining, and working all the angles as a Milwaukee public relations hack and fund-raiser. Clair Richardson was one of a kind in suit and tie, but when he founded the Skylight Comic Opera Theatre he loosened his collar and never looked back. (Courtesy of Skylight Opera Theatre.)

Although it might have seemed that Richardson did everything on a whim, he carefully cultivated everything in his life. The Bohemian rags he loved to wear as his daily uniform were often pulled out of the Skylight's costume stock. When he decided to make Skylight a viable arts group, he decided he would do it his way. That meant he had his hand in everything. (Courtesy of Skylight Opera Theatre.)

Richardson having his hand in everything at Skylight meant any manner of things. One moment he could be casting chorus members for a production of *The Mikado*. The next minute he could be fixing a light in the theater or scribbling ticket sales in a little spiral-bound notebook. His favorite duty as producer was getting to know the pretty girls who worked on Skylight's stages. (Courtesy of Skylight Opera Theatre.)

If ever there was a real live version of Max Bialystock, the rapscallion producer from Mel Brooks's *The Producers*, it was Clair Richardson. Richardson's schemes included a summer opera festival at the Performing Arts Center in the early 1970s. Here he is entertaining the international cast, many whom did not speak English. That did not bother Richardson; he just spoke a little louder. (Courtesy of Skylight Opera Theatre.)

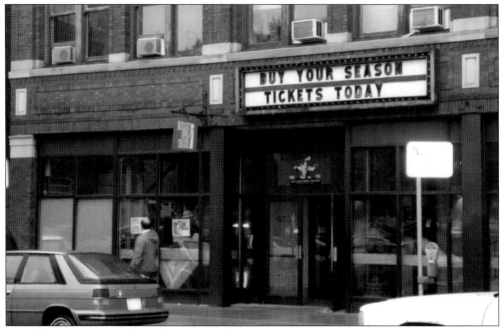

The Skylight Comic Opera Theatre moved around to different makeshift venues in its early years before settling on its Cathedral Square home (above). The building had been an automobile garage at one point in its architectural life, and the site's unwieldy spatial configuration was one of the many quirky charms of experiencing the Skylight. Selling adventurous opera and musical theater was the business plan that Clair Richardson had in mind when he set off to create his arts place of fun. But when times got tough and Richardson felt the need to tighten his belt another loop, the theater focused its attention on plant sales (below). (Courtesy of Skylight Opera Theatre.)

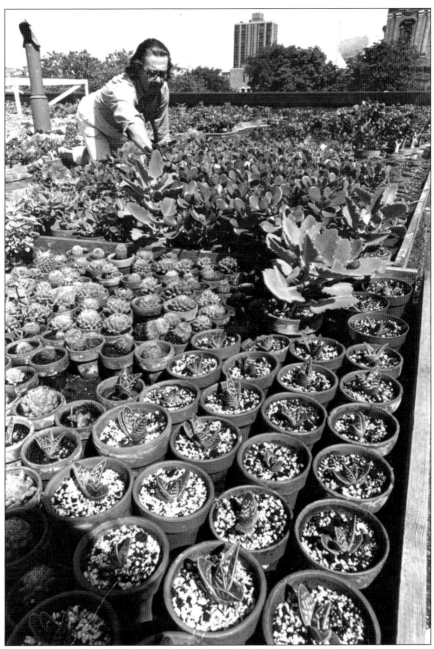

Richardson tended to his rooftop garden with zealotlike devotion. At times it seemed that his head never hit a pillow. Or, if it did, there invariably seemed to be a chorus girl staring him in his horn-rim-covered eyes for some affair to remember. Richardson's reputation as a lothario was self-inflicted at times. He had a heart attack at one point and a Skylight singer, wanting to help run the theater while Richardson recuperated, said, "Don't worry, I can do everything you do while you're gone to keep this place afloat." Richardson responded with characteristic panache, "Can you make love to a little old lady?" Because of his many charming character quirks, he was able to schmooze performers into working for peanuts so they could do artistically thrilling productions. (Courtesy of Skylight Opera Theatre.)

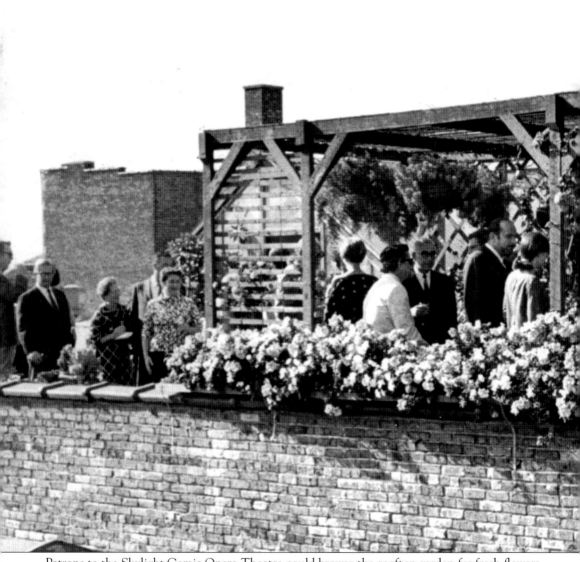

Patrons to the Skylight Comic Opera Theatre could browse the rooftop garden for fresh flowers or plants for their front stoop. Clair Richardson was a master of making people believe that there was no finer artistic experience in Milwaukee than the one he had created. There is no doubt that he had a tremendous ego and a bark that could be heard right through the clouds

of cigar smoke he generated daily, but he had something else that kept the Skylight together in the slimmest of times. Richardson had a showman's heart that beat time along with the many musical theater pieces he helped to bring to life. (Courtesy of Skylight Opera Theatre.)

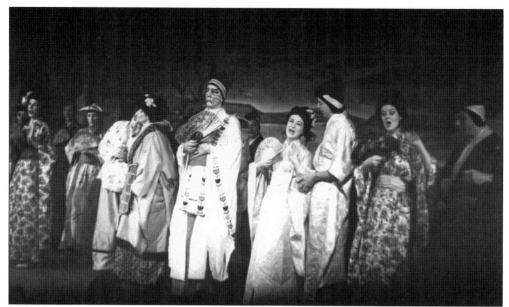

These early photographs of Skylight performances dating back to the early 1960s show what the theater was best known for when it began: Gilbert and Sullivan. *The Mikado* (above) and *The Pirates of Penzance* (below) each were presented early in the Skylight's production chronology and would then make several return engagements over the years. Over a nearly 50-year performance history, the Skylight has not veered off the Gilbert and Sullivan path and makes a habit of including one of the dynamic duo's witty song and word constructions in each of its yearly seasons. (Courtesy of Skylight Opera Theatre.)

The Skylight's artistic lineup was never simply defined by jaunty patter songs and silly foppery. On the other end of the programming coin, the Skylight made a name for itself with brave, raw productions of socially conscious musicals like *The Threepenny Opera* (at right) and *Happy End* (below). These demanding Kurt Weill musicals benefited from the talents of poised hometown Milwaukee singers like Kurt Ollman (pictured below, right) whose international singing career was highlighted by recordings with Leonard Bernstein and appearances on many of the major opera stages of the world. Skylight audiences were fed a diet of fun and froth as well as grit and pathos from the earliest days of the company's formation. This blend of light and dark material helped Skylight stick out as a maverick company. (Courtesy of Skylight Opera Theatre.)

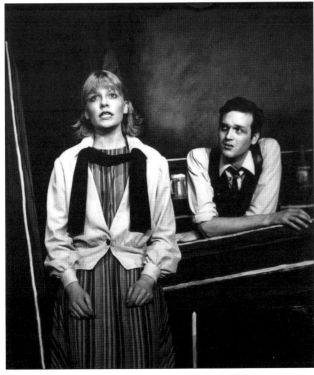

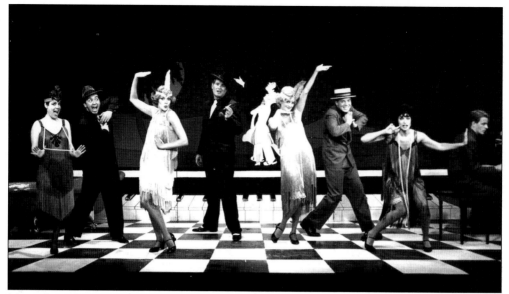

Musical reviews were always a popular source of fun for Skylight audiences. Sometimes they were generated from within, as was the case with composer James Valcq's *Bathtub Gin Revue* (above). Hometown boy Valcq also composed the campy musical *Zombies from Beyond* for the Skylight, which eventually enjoyed a short off-Broadway run in New York. With years of great practical work under his belt at Skylight, the composer would eventually establish himself as a serious composer with critically acclaimed *The Spitfire Grill*. When Valcq or other Skylight music makers were too busy making tunes to put together clever musical revues, the Skylight turned to pieces like *Tintypes* (below) that recalled nostalgic songs from bygone times. (Courtesy of Skylight Opera Theatre.)

There is a pineapple for everyone in this production shot from the Skylight's 1989–1990 season production of *Cabaret*. Actors Beryl Brennan, C. Michael Wright, and Yaakov Sullivan were indicative of the type of well-rounded performers the Skylight was always known for attracting. All performers learned quickly in the Skylight's intimate space that good acting was just as important as good singing. (Courtesy of Skylight Opera Theatre.)

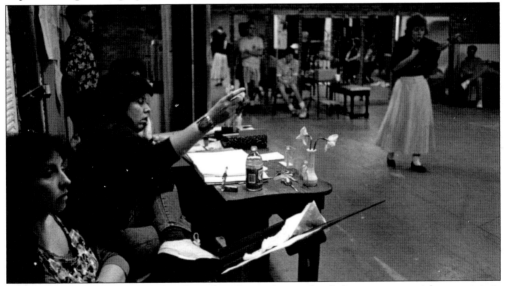

In the mid-1980s, the Skylight elected to focus the work of the company with a coartistic directorship. Up-and-comers Stephen Wadsworth and Francesa Zambello were brought in to maintain the spirit that Clair Richardson had tended to during his colorful life. Francesca Zambello, seen here directing a Skylight rehearsal, became an internationally sought after director of opera and musical theater after her stint as a Milwaukee arts leader. (Courtesy of Skylight Opera Theatre.)

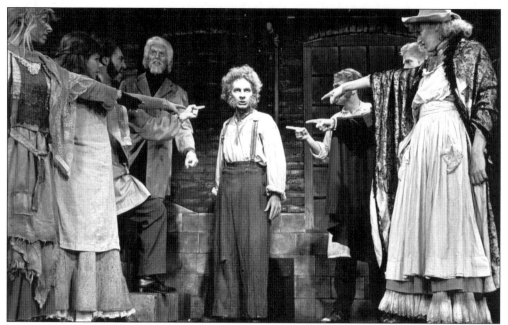

By the time this 1986 production of *Sweeney Todd* was presented by the Skylight, it was getting harder and harder to get a seat for any of the theater's productions because so many patrons liked their music and theater served with a twist. A search for a new home was the result of Skylight's success. (Courtesy of Skylight Opera Theatre.)

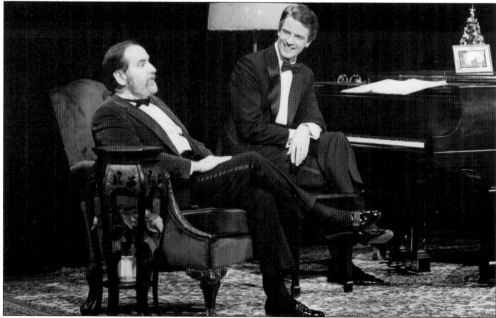

For the Skylight, there was Clair Richardson, and then there was Colin Cabot (pictured on right with Milwaukee Chamber Theatre's Montgomery Davis). When Richardson needed to hand over the reins to the Skylight, the heir apparent was Colin Cabot. His unending talents as a musician and society operator brought a new level of class to the Skylight. (Courtesy of Skylight Opera Theatre.)

Colin Cabot was rarely seen without his signature bow tie in his years leading the Skylight as a manager and master fund-raiser. Here he is preparing for a funding event dedicated to generating income for the jewel box space that would become Skylight's new home in 1993. (Courtesy of Skylight Opera Theatre.)

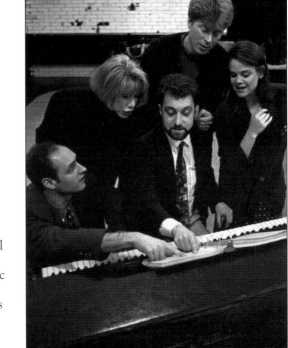

While many of the Skylight gang was thinking about building a new home, the artists that made the place the thrill seekers' answer to artistic satisfaction continued to wow audiences. Here music director and eventual artistic director Richard Carsey (center with beard) goes over music with performers for a South American tour. (Courtesy of Skylight Opera Theatre.)

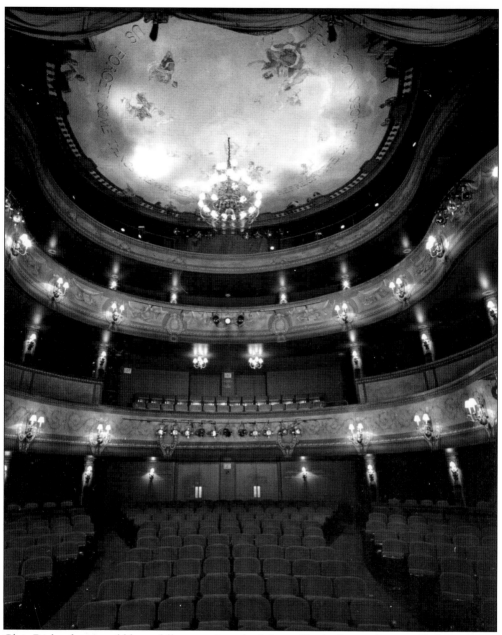

Clair Richardson would have fallen over in a dead faint if he had seen the new Skylight Opera Theatre that opened in Milwaukee's Third Ward in 1993. The first production in the Cabot Theater, named for Colin Cabot's masterful fund-raising for the intimate European-styled chamber music and theater space, was Mozart's *The Magic Flute*. The Cabot Theater is the centerpiece of what Milwaukee audiences know as the Broadway Theater Center. That shared performing arts building includes a 99-seat performance space called the Studio Theater. The building was originally intended for use by the Skylight, Milwaukee Chamber Theatre, and Theatre X, but in subsequent years became an increasingly popular rental property. Richardson always looked down on the proceedings from a prime ceiling seat as a caricatured cherub in an artistic depiction of the city of Milwaukee. (Courtesy of Skylight Opera Theatre.)

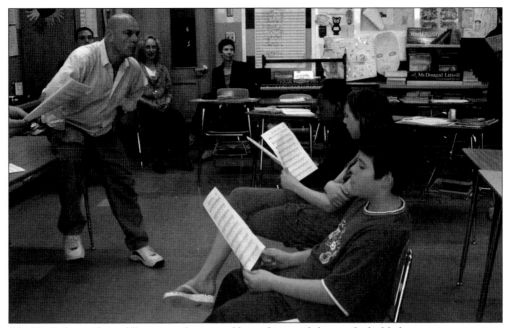

The Skylight made itself known to legions of fans of musical theater for bold, daring programming. As it moves forward into the next stage of its life as a theater that has thrived for nearly 50 years, the Skylight adds innovative arts education outreach to its list of accomplishments. Here education director Ray Jivoff helps students understand musical structure and qualities to consider in a song. (Courtesy of Skylight Opera Theatre.)

After so much hard work, one would think that Clair Richardson might deserve a break from Skylight. But this was not the case when the company he founded moved into its new home in 1993. Richardson's ashes were ceremoniously couriered to the Cabot Theater for their final rest prior to the building opening. The urn is displayed underneath the stage in a shrine that would please him greatly. (Courtesy of Skylight Opera Theatre.)

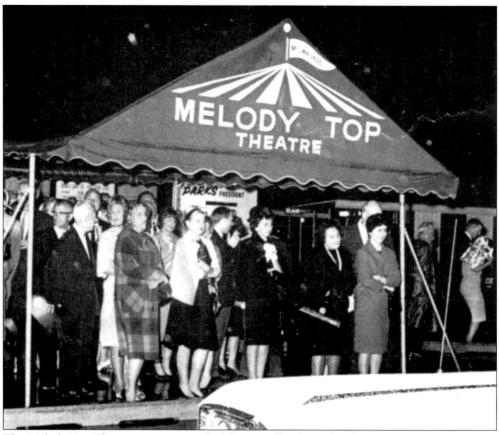

The Melody Top Theater was an entirely different affair from the Skylight. Melody Top moved into Milwaukee in 1963 and was modeled on an identical tent theater outside Chicago that had members of the Cominsky family as some of its serious investors. The management of the Melody Top promised to produce Broadway-quality presentations of big-scale musical hits. Similar to the Fred Miller Theatre to the south, this north side Milwaukee summer season venue operated on a star system. Opening-night audiences included high-ranking local government officials who would often host private fund-raising events in association with performances. The aerial view of the Melody Top brings to bear the fact that the theater was indeed an oversized tent. (Courtesy of Sue Godfrey.)

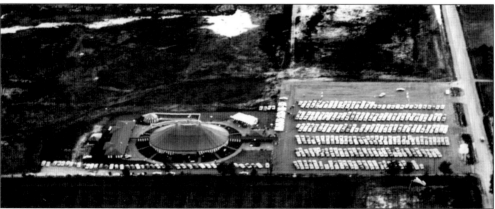

Driving past the Melody Top, it might have seemed to the casual observer that the tent theater was a comical roadside attraction like any number of man-made wonders of the world. The Melody Top's lit entrance sign recalled a low-rent casino beacon. But the producers and promoters behind the Melody Top were anything but a group of babes in the woods. After Melody Top nearly ran out of money in its first two seasons, backing by Milwaukee businessman William Luff put the theater on sounder footing for producers including Stuart Bishop, Martin Wiviott, and Guy Little. The Melody Top became a household name in Milwaukee with department store displays, numerous promotions, and wide-reaching publicity like the Milwaukee City Hall announcement shown here. (Courtesy of Sue Godfrey.)

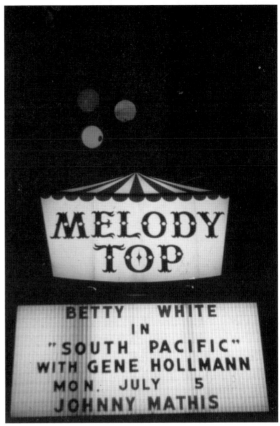

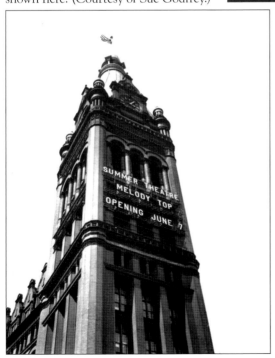

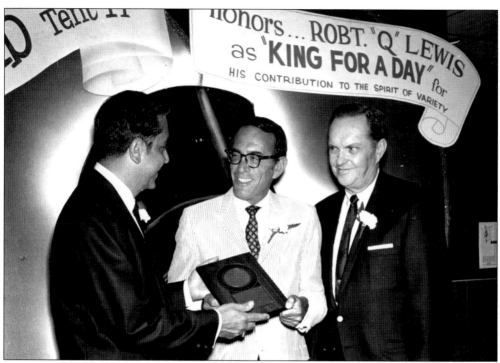

Robert Q. Lewis was one of the stars to play at the Melody Top. Melody Top producers made sure that their stars connected to the community. Here Lewis is honored as king for the day for his contributions to the spirit of variety. (Courtesy of Sue Godfrey.)

Membership in the Ringmaster Club was akin to having a key to the Playboy Club. Ringmaster Club members were invited to special events and got to drink at the special Ringmaster's cocktail tent prior to shows and during intermission. (Courtesy of Sue Godfrey.)

Starting with its first production, *Guys & Dolls*, starring Gordon and Sheila McRae, the Melody Top attracted serious talent for its limited-run performances. Seeing John Raitt in *Oklahoma* at Melody Top was not just the next best thing to seeing the original—it was just as good. Major stars of the American musical theater who played Melody Top in addition to Raitt and the McRaes include Stubby Kaye, Chita Rivera, and Martha Raye (below). A program for an early production of *West Side Story* even lists a young Christopher Walken as Riff before his notorious career in movies. The entertainment industry was not so heavily tilted toward working in television and film in the 1960s, and actors still felt they could survive by touring the nation doing plays and musicals in places like the Melody Top. (Courtesy of Sue Godfrey.)

SEPT. 2nd THRU SEPT. 14

# JOHN RAITT

IN

"OKLAHOMA"

LAST DAY—AUG. 31st
"SONG OF NORWAY"

ces: Tuesday thru Friday, 8:30 p.m.
turday, 6 p.m. and Sunday, 7:30 p.m. —
.40, $3.30, $2.20.

turday, 9:30 p.m. $5, $4, $3.

kets can be ordered at: BOSTON STORE
Downtown, Point Loomis and Boston
lage; VAN'S GIFT SHOP, 2624 N.
wner Ave.; ALL SEARS STORES in the
Iwaukeeland area including Racine,
nosha, Menomonee Falls and Burlington.

MELODY TO
THEATRE
7201 W. Good Hope Rd
353-7700

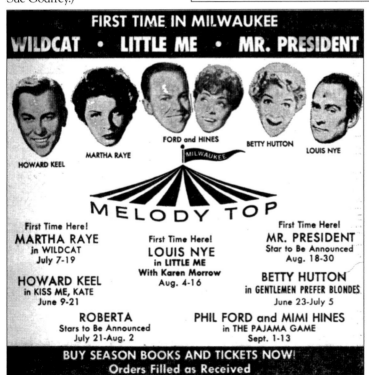

FIRST TIME IN MILWAUKEE
WILDCAT • LITTLE ME • MR. PRESIDENT

HOWARD KEEL

MARTHA RAYE

FORD and HINES

BETTY HUTTON

LOUIS NYE

MELODY TOP

First Time Here!
**MARTHA RAYE**
in WILDCAT
July 7-19

First Time Here!
**LOUIS NYE**
in LITTLE ME
With Karen Morrow
Aug. 4-16

First Time Here!
**MR. PRESIDENT**
Star to Be Announced
Aug. 18-30

**HOWARD KEEL**
in KISS ME, KATE
June 9-21

**BETTY HUTTON**
in GENTLEMEN PREFER BLONDES
June 23-July 5

**ROBERTA**
Stars to Be Announced
July 21-Aug. 2

**PHIL FORD and MIMI HINES**
in THE PAJAMA GAME
Sept. 1-13

BUY SEASON BOOKS AND TICKETS NOW!
Orders Filled as Received

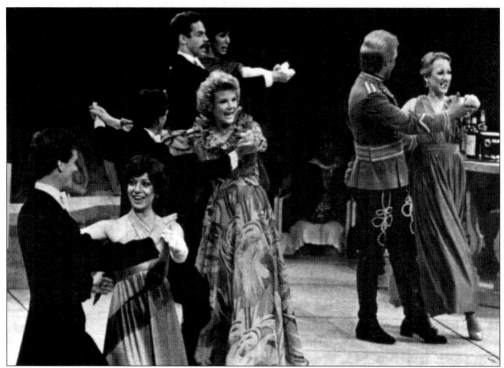

Audiences at the Melody Top sat in the round watching stars like Nannette Fabray dance and sing. The tent theater had its charms but was full of flaws. If rain would start to pour during a performance, patrons felt like they were sitting in a drum. (Courtesy of Sue Godfrey.)

Shows like *Sweet Charity* delighted audiences coming from surrounding suburbs. It is no surprise when one considers that the resident choreographer at Melody Top in its early days was lanky Texan Tommy Tune, who would graduate from creating tent dances to becoming one of Broadway's leading directors. (Courtesy of Sue Godfrey.)

By the mid-1980s, times had changed for places like the Melody Top. Where at one time it would have been easy for the Melody Top to attract actors to reprise roles they had originated in musicals that premiered on Broadway, now it was becoming more and more difficult to lure performers away from the bright lights of Hollywood and New York. Headliners in the 1980s were typically soap opera stars like Susan Hayes, who performed alongside her husband Bill in *Oliver!* Over the years, however, Melody Top producers continued to get their performers involved in any possible pregame anthem and supermarket opening just to promote their shows. The young urchin cast of *Oliver!* joined the Milwaukee Brewers baseball team for some harmonizing before the first pitch. (Courtesy of Sue Godfrey.)

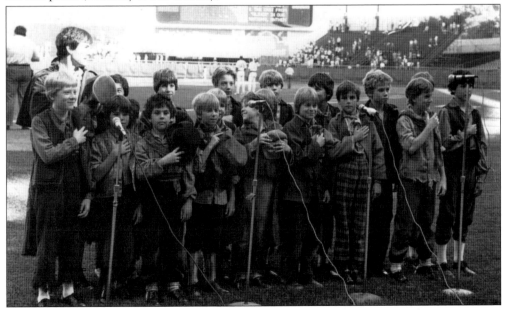

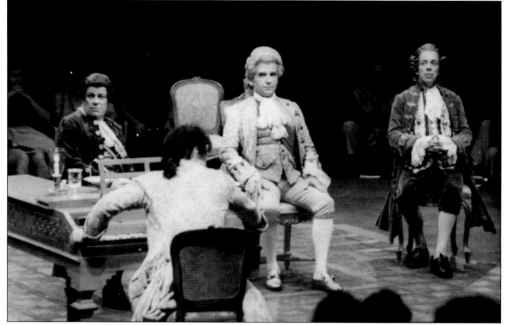

Melody Top promoted the use of stars and starlets in its shows, but the sprawling casts of the shows it chose to produce required the participation of local talent. Local character men Durward McDonald, Montgomery Davis, and William Leach are pictured here in a Melody Top production of *Amadeus*. (Courtesy of Milwaukee Chamber Theatre.)

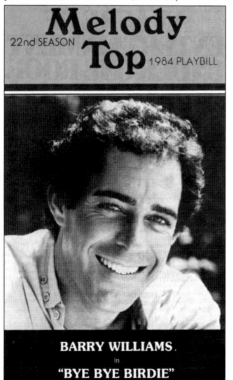

By 1987, the Melody Top was no longer the "it" place for Milwaukee's society set to rub elbows and do deals while waiting to get into the Ringmaster's Club. The theater ended its run not long after its great benefactor William Luff died and financial hardships forced closure. Not even Barry Williams could save the big top theater from modern times. (Courtesy of Sue Godfrey.)

# Four

# LEARNING THE CRAFT

As young men and women looked around at the theater opportunities available to them in Milwaukee after the middle part of the 20th century, many of them knew they wanted to be a part of all the excitement. Recognizing that energy and a community desire to be well-educated artists and audiences, Milwaukee colleges and universities responded fully to the call for advanced training in the theater arts.

From the early 1950s through the 1980s, an eager young actor or actress seeking the guiding hand of a passionate teacher could choose from three extraordinary college theater programs. Their aesthetics were all different, but the leaders of these three programs, Fr. John Walsh, Robert Pitman, and Sanford Robbins, all believed in the nobility of a career in the theater and worked tirelessly to instill in their students a love and appreciation for the rigors and rewards of hard work.

At Marquette University, Jesuit instructor Fr. John Walsh took over the reins of the Marquette University Players in 1951 and made all their productions must-see events. In the 1960s and 1970s, as theater director at the all-women's Alverno College, Robert Pitman decided the best way to help his students learn theater was to do theater. Pitman's glorious productions had student actors performing side by side with his own committed repertory company of local community talent.

Walsh and Pitman were innovators at Marquette and Alverno, respectively, but Sanford Robbins did something else at the University of Wisconsin-Milwaukee in the 1980s. He created a corps of the finest trained actors in the country who would infiltrate the Milwaukee performance community and shape it in ways no one ever anticipated. Robbins's brainchild, the Professional Theater Training Program (PTTP), brought a new level of training and theatrical know-how to the Milwaukee acting community that has endured as artists from that program have stayed in town to work and form their own companies. These three men helped all their students understand that theater, when tackled head-on as serious business, is a powerful life force that can soften even the most hardened of hearts.

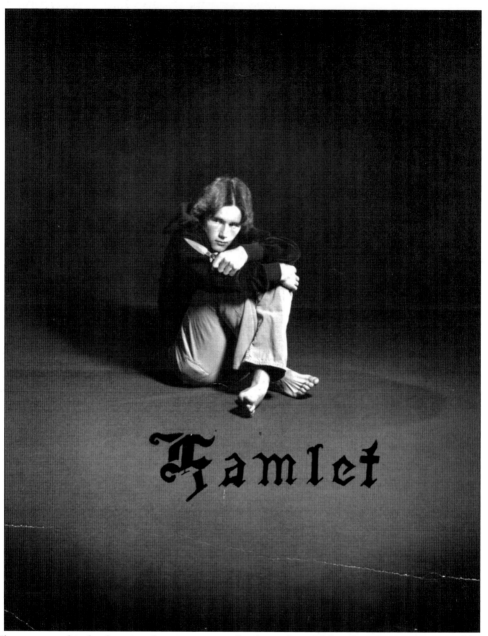

# Hamlet

There are two kinds of stories when it comes to thinking about Milwaukee theater artists tackling the daunting task of learning and living with their craft. One tale is evident in contemplating this photograph of a 17-year-old Mark Rylance on the cusp of performing his first *Hamlet*. Rylance was a student at Milwaukee's university school who started to dabble in drama in his teen years. He was bold to say the least in assaying the role of the melancholy Dane as a mere youth, but there was something prophetic in that youth-inspired leap of faith. Rylance would leave Milwaukee and end up serving as artistic director of England's Globe Theater. Many people consider him the greatest Shakespeare interpreter of his generation. In 2008, Rylance won a Tony Award for his Broadway debut in *Boeing! Boeing!* One has to wonder if any of that would have been possible without a kick start in Milwaukee. (Courtesy of Dale Gutzman.)

The other type of story that says much about the quality of life in Milwaukee for theater artists concerns a journeyman actor like Norman Moses. Whether he is seen as a swaggering young actor (at right) or later as an accomplished entertainer in Milwaukee Chamber Theatre's 1983 production of *Clarence* (below), Moses is the consummate Milwaukee actor. Moses grew up in a suburb of Milwaukee and essentially never left. He attended high school in the area, performed in plays with a myriad of community organizations, and went on to study acting at University of Wisconsin-Milwaukee's PTTP. His contributions to the city as an artist are legendary, and his involvement in the community is profound. Moses, like many theater artists, found that the best place to grow, learn, and work as an artist is Milwaukee. (At right, courtesy of Dale Gutzman; below, courtesy of Milwaukee Chamber Theatre.)

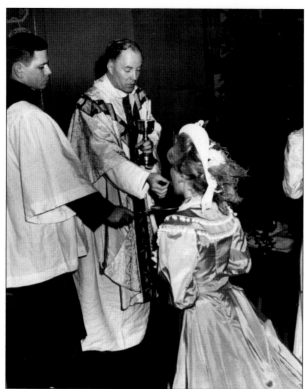

Serving mass does not seem like the work of a leading theater educator, but it was just part of Fr. John Walsh's job description as the priest in charge of Marquette University's theater program. Father Walsh offered communion to his student actors prior to a performance at the city's Jesuit-run university. (Courtesy of Marquette University Archives.)

Father Walsh was a Yale-educated theater artist who transformed the Marquette University Theater Department into a place for dedicated exploration of craft. Seen here in a dance class with bemused students, Father Walsh practiced the discipline that he always taught and proved that good acting came from good training. (Courtesy of Marquette University Archives.)

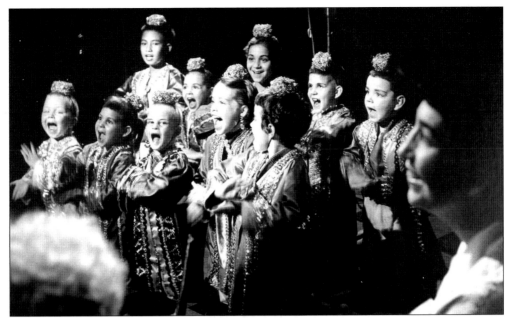

When Father Walsh took over the Marquette University Players in 1951, it was largely an extracurricular activity for students who enjoyed drama. Walsh demanded hard work and a commitment to excellence. To grow Marquette's theater, Walsh produced plays and musicals on a big scale, often involving people from the community like the children pictured here who performed in *The King and I* and *Peter Pan*. Walsh also moved the Players' productions into a new theater in Bellarmine Hall that he christened Teatro Maria. He built an open-air courtyard theater that allowed students to explore the rigors of performing outdoors. At the time, Walsh's productions were said to rival the quality of the newly formed Fred Miller Theatre. (Courtesy of Laura Purdy for Walter Sheffer Estate and Marquette University Archives.)

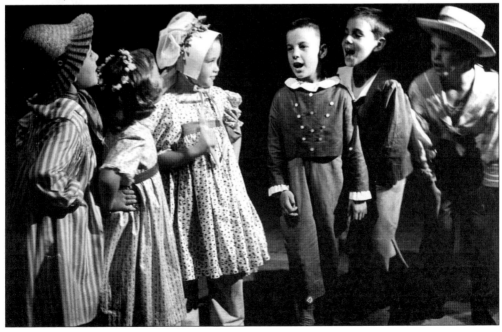

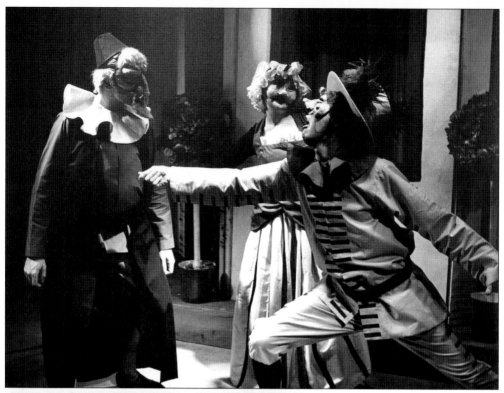

Fr. John Walsh's productions of *Sgnarelle* (above) and *The Threepenny Opera* (below) are well documented, thanks to a perfect union of photographer and theater director. Walsh's commitment to excellence translated into all areas of theatrical production, so when considering how to capture publicity and archive images of plays the Marquette Players presented, Walsh thought a true artist should do the work. He turned to Milwaukee portrait photographer Walter Sheffer, who would collaborate with Walsh as photographer for nearly all his productions. Sheffer's images capture for all time the true artistry that Father Walsh demanded of himself and his students. (Courtesy of Laura Purdy for Walter Sheffer Estate and Marquette University Archives.)

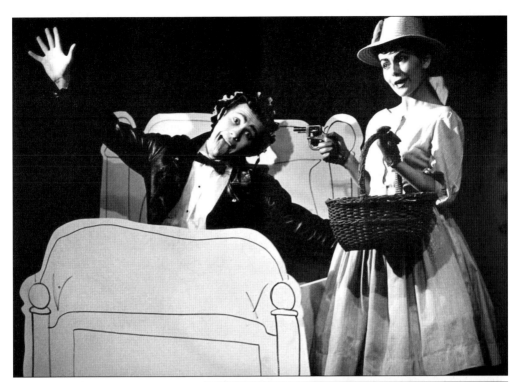

Walsh's artistic programming as head of the theater department at a Jesuit-run university was more freewheeling than one might expect. Productions of plays like *A Thurber Carnival* (above) played against inspirational faith-driven tales like *Saint Joan* (at right). There was no formula for the type of theater Father Walsh thought was worthy of presentation. A look at the full list of productions he directed or oversaw as the theater department chair at Marquette from 1951 to 1965 includes hard-nosed dramas, screwball comedies, and big-scale musicals. He gave his students every opportunity to explore the many facets that a career in theater might offer them by programming a wide range of theatrical styles in his students' educational plan. (Courtesy of Laura Purdy for Walter Sheffer Estate and Marquette University Archives.)

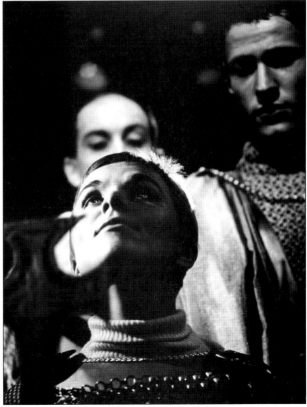

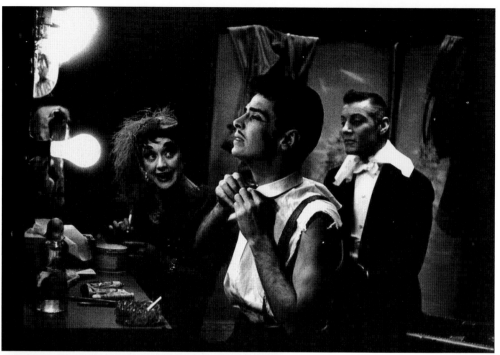

Fr. John Walsh gave much of himself to the Marquette community, and he ultimately gave the professional theater world several well-prepared artists to join its ranks. Collette Kerry, Stewart Moss, and Harry Eldon Miller prepare for a performance backstage in this intensely theatrical snapshot of the preparation actors do before they hit the footlights. Stewart Moss left Marquette and distinguished himself as a successful director. His classmate Peter Bonerz, seen at left in *Alarms and Diversions*, was well known to television fans as Jerry the dentist from *The Bob Newhart Show*. Bonerz also became an in-demand television and stage director. (Courtesy of Laura Purdy for Walter Sheffer Estate and Marquette University Archives.)

While Walsh was driving the theater education of students at Milwaukee's leading Catholic university, an unlikely theater legend was transforming students' perceptions of theater on the south side of Milwaukee at Alverno College. What was most unlikely about Robert Pitman's success as theater director of Alverno College was that the all-female student body took to his intrepid theatrical adventures with gusto. Robert Pitman had a career as an actor and a director outside the scholastic realm that he ultimately found himself in at Alverno College, but it was around the Alverno girls and his beloved colleagues, "the nuns," that he had his most profound impact as a theater artist. (At right, courtesy of Norman Moses; below, courtesy of Alverno College Archives.)

Robert (Bob) Pitman's students knew where they stood with their beloved leader. Indeed, everyone knew where he or she stood with Pitman because he was widely known for his refreshing and forthright candor. Whether one was a student or friend, they could be certain that if Robert Pitman did not like what they were doing onstage, he would tell them so straight to their face. (Courtesy of Alverno College Archives.)

The students Pitman worked with were college-aged co-eds considering a career in the theater or, as seen here in a rehearsal for *Help, Help the Gobolinks* in 1971, school-aged children hoping to capture the drama bug. With his ever-present cigarette in hand, Pitman treated plays like *The Gobolinks* with the same passion as he would any of the works of Shakespeare. (Courtesy of Alverno College Archives.)

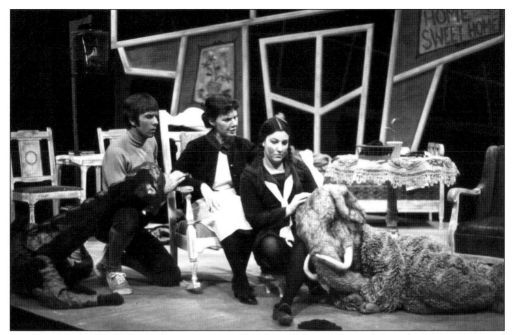

Pitman's answer to filling out his casts at an all-girls college was to reach into the community and utilize the talents of actors and actresses looking for new theatrical adventures. These unpaid talents became part of Pitman's ad hoc repertory company. Ruth Schudson (center), a frequent Pitman collaborator, is seen here in a production of *Skin of Our Teeth*. (Courtesy of Alverno College Archives.)

On occasion, Pitman would join the student and local actor ensembles. He was locally in demand as an actor with Skylight Comic Opera Theatre and the Melody Top. His commanding presence in *Arms and the Man* was an opportunity for him to show his students the practical application of his many engaging lessons on the proper way to attack a role with integrity and professionalism. (Courtesy of Alverno College Archives.)

*King Lear* at a women's college? One could get away with it if they were Robert Pitman. Pitman had the charm and class to make people understand that by taking great chances in the theater they risked the chance of becoming smarter, more engaged students of life. That attitude made Pitman an ally of the nuns who were his Alverno teaching colleagues. (Courtesy of Alverno College Archives.)

Pitman loved spectacle and was intimately involved in all aspects of production. The performers in this Pitman-directed production of *The Golden Apple* surely were well instructed by Pitman in how to wear their hats, the best way to tie their ties, and the value of standing up straight. Pitman was described by his many adoring fans as an impeccable gentleman in every regard. (Courtesy of Alverno College Archives.)

In his time as theater director, Pitman made good friends with talented artists like Beryl Brennan, Harry Zumach, and Ruth Schudson, all of whom he directed in *Old Times*, one of his final Alverno productions. After serving as theater director from 1963 to 1974, Pitman then served as academic dean of Alverno College until his death in 1978. (Courtesy of Alverno College Archives.)

A performance of scenes from some of Pitman's greatest triumphs as theater director of Alverno College preceded the naming of the college theater in his name at a celebratory memorial service. In life, Pitman had brought together people looking to learn more about the theater from the worlds of academia and "normal life" and asked them to work hard and do their best. (Courtesy of Alverno College Archives.)

# WE WANT YOU!

## to help train the class of '87

The "we" in this advertisement is the students in the 1987 class at University of Wisconsin-Milwaukee's PTTP. In the 1980s, the university's PTTP ranked as one of the top graduate-level training programs for men and women serious about a professional career in the theater. The era of PTTP in Milwaukee during the years of leadership by its founder, Sanford Robbins, is a much-admired period of artistic achievement in Milwaukee theater. Students in the program dedicated to an intense three-year course of study that focused their energies toward understanding technique and rigorous discipline. Some of the training seemed absurd to observers who picked up tales of young actors wailing just so they could understand how to be better actors. What was not absurd were the results. (Courtesy of Norman Moses.)

Theater at the University of Wisconsin-Milwaukee prior to a formalized training program meant production after production with no agenda that dictated a training plan. Guest artists with a national stature would occasionally join the university actors for a production. Alvin Epstein (center) performed in a University of Wisconsin-Milwaukee Summer Arts Guild production of *Enrico IV* in 1961. (Courtesy of University of Wisconsin-Milwaukee Archives.)

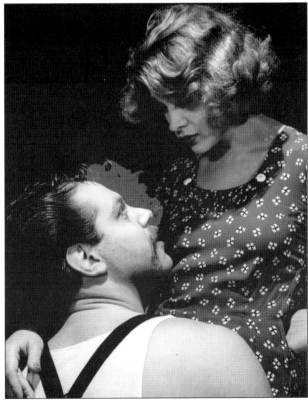

When the PTTP came into fashion, students were put front and center as the focus of performance. This meant that students assumed all the responsibilities that professional actors and actresses do. Students like Brian Mani and Carrie Hitchcock performed challenging contemporary and classical works. The community came and saw their plays, and for a time many people thought the work they were doing was superior to that of Milwaukee Repertory Theater. (Courtesy of Norman Moses.)

Because of the demands of the work, students bonded tightly and had an easy shorthand with each other that actors who work together for years strive to feel. Not every moment was filled with making their bodies and minds instruments of understanding strength, however. Here PTTP students learn the time-honored actor tradition of doing the crossword puzzle backstage. (Courtesy of Norman Moses.)

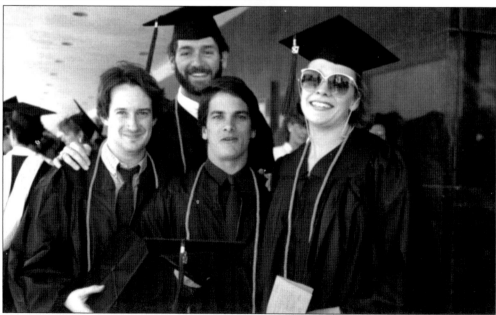

On graduation day, no one knew what would become of these four PTTP grads. They all continued to act and, thankfully for local audiences, most of their acting happened in Milwaukee and the state. Among their accomplishments were triumphs as vagabond actors, memberships in resident companies in Milwaukee and Wisconsin, and for one broad-minded grad, a second career as a nurse with esteemed acting credentials. (Courtesy of Norman Moses.)

Students in the PTTP's Japanese-themed take on *Macbeth* (above) had the benefit of studying combat techniques with master teachers. Students coming into the PTTP with bad acting habits had a good chance of having them drilled out of their bodies by the almost military-like regard for craft. Teachers made demands of students to be prepared, show up ready to work, and to focus on the content in class. This well-trained group of actors left the University of Wisconsin-Milwaukee with a fire in their bellies to perform, and to perform well. Their presence in the acting community started to force others to "raise the bar" and try to achieve greater professionalism in all work around town. (Above, courtesy of Laurie Birmingham; below, courtesy of Norman Moses.)

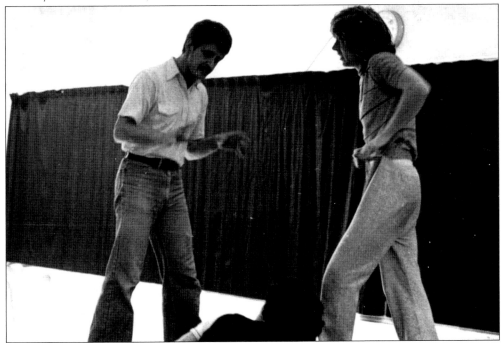

The original PTTP lasted in Milwaukee only through the 1980s before the founders of the program transferred their program to the University of Delaware. Future classes of students in revised models of the PTTP at the University of Wisconsin-Milwaukee would carry forward with memories of complex productions of challenging work led by international artists, and tales of hours upon hours of Suzuki training. The original PTTP students stayed in Milwaukee and forced all Milwaukee theater artists to work harder to be better. It was a win-win situation for both city and artists. (Above, courtesy of Norman Moses; below, courtesy of Laurie Birmingham.)

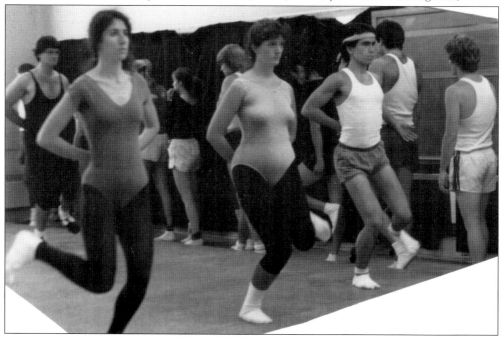

# Five

# GETTING THEM WHILE THEY ARE YOUNG

Milwaukee men and women have not been the only beneficiaries of a healthy theater scene. Milwaukee boys and girls have also greatly benefited from a citywide drive to perform theater for audiences of every age with a nod to professionalism and unending creativity.

In the days of the Fred Miller Theatre, nighttime audiences enjoyed popular contemporary plays and interesting interpretations of classics. During the day, however, the Pick-A-Pack Players children's theater company took over and gave the kids of the parents enjoying all the Fred Miller Theatre's plays a taste of what their moms and dads were raving about. Pick-A-Pack did not follow the path to the Performing Arts Center when Milwaukee Repertory Theater would move from the Fred Miller into the newly constructed downtown arts complex in the late 1960s. That lack of a move proved fatal to the stability of this early children's theater group, and after performing at other venues and at outdoor festivals around town for several years, Pick-A-Pack Players fell off the radar of Milwaukee performance companies.

This children's theater programming void would ultimately be filled in a major way with several successful children's theater ventures. Milwaukee earned a national reputation in the 1970s and 1980s as a premier incubator for touring children's theater productions when the Great American Children's Theater Company was formed. The founders of the Great American Children's Theater Company believed in the notion that children's theater must be presented with the same commitment to excellence that drives the production of professionally produced adult-oriented theater. To that end, the company presented plays and special events for children that rivaled any local professional theater presentations during its successful Milwaukee-based production run through the early 1990s.

Since 1987, children's theater programming in Milwaukee has most prominently been linked with First Stage Children's Theater. First Stage Children's Theater has taken the practice of theater entertainment and education for youth off the charts, introducing the arts to thousands of Milwaukee boys and girls through its beautifully produced plays and the work of its Theater Academy.

The Pick-A-Pack Players thrived when they performed at the Fred Miller Theatre under the wing of Milwaukee Repertory Theater. Touring and performing in outdoor venues proved to be challenging for the stability of this early children's theater troupe. Pick-A-Pack's imaginative presentations stressed mindful invention over overblown spectacle. When the company folded in the early 1970s, several children's theater initiatives carried on the noble mission of introducing Milwaukee children to theater. This early troupe helped Milwaukee audiences understand that when theater was introduced to audiences at a young age it would be more apt to be a part of a person's adult life. (Courtesy of Dale Gutzman.)

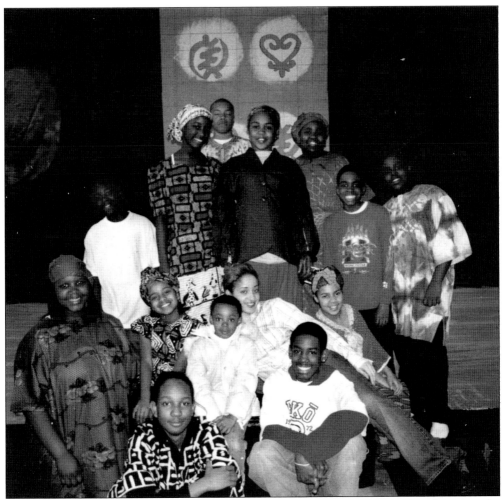

The African American Children's Theater Company has a rich tradition of performing tales steeped in the traditions of the African American community in Milwaukee. Milwaukee's theater community has supported the African American Children's Theater Company as well as African American adult troupe Hansburry Sands Theater Company. The African American Children's Theater has performed original work that often utilizes music and dance for touring productions throughout Milwaukee for nearly 20 years. The troupe trains its young performers to be responsible citizens and offers accessibility to its programming through low ticket prices, free performances, and affordable participation for student actors. (Courtesy of African American Children's Theater.)

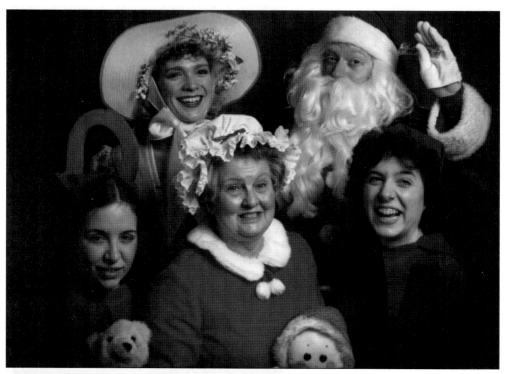

The Great American Children's Theater Company (GACT) did touring shows and special theatrical events from the mid-1970s through the early 1990s. *Breakfast with Santa* (above) was a grand affair that was a fun and loving holiday experience for children and adults alike. The Pabst Theater was GACT's Milwaukee home base. They performed magical interpretations of well-known children's tales like *Charlie and the Chocolate Factory* (at left) in that historic theater for busloads of schoolchildren before taking their shows on multistate tours. The troupe advocated professional standards in all areas of theatrical presentation for young audiences. (Above, courtesy of Norman Moses; at left, courtesy of University of Wisconsin-Milwaukee Archives.)

*Jingle Bear Revue* was one of the productions of Next Generation Theater. Next Generation came out of the merger of Theatre Tesseract and Next Act Theatre in the late 1980s. Audiences were confused by Next Generation, not understanding how it fit into the mission of the adult-oriented Next Act Theatre. Next Act officials agreed, and Next Generation became a short-lived venture. (Courtesy of University of Wisconsin-Milwaukee Archives.)

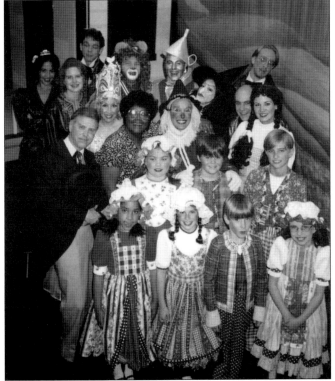

M&W Productions started as an offshoot of the Melody Top. When the Melody Top folded in 1987, M&W continued producing traditional stories for child audiences. Its production of *The Wizard of Oz* recalled the well-known story while creating new images and songs for its own special presentation. (Courtesy of J. T. West.)

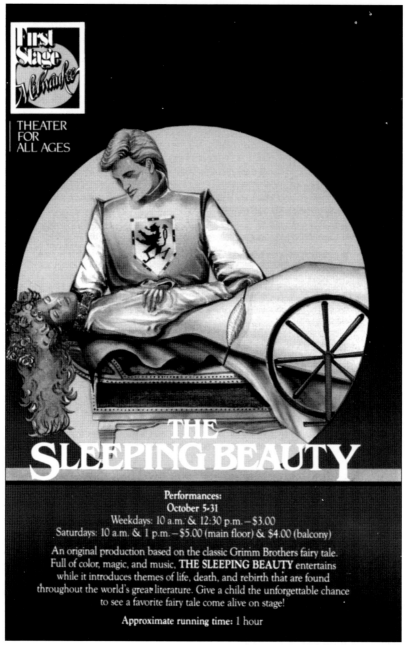

First Stage Milwaukee

THEATER
FOR
ALL AGES

THE
SLEEPING BEAUTY

Performances:
October 5-31
Weekdays: 10 a.m. & 12:30 p.m. – $3.00
Saturdays: 10 a.m. & 1 p.m. – $5.00 (main floor) & $4.00 (balcony)

An original production based on the classic Grimm Brothers fairy tale.
Full of color, magic, and music, **THE SLEEPING BEAUTY** entertains
while it introduces themes of life, death, and rebirth that are found
throughout the world's great literature. Give a child the unforgettable chance
to see a favorite fairy tale come alive on stage!

**Approximate running time: 1 hour**

When Milwaukee Repertory Theater moved from the Todd Wehr Theater of the Performing Arts Center in 1987, a hole needed to be filled. The president of the Performing Arts Center at that time, a hands-on administrator by the name of Archie Sarazin, solicited many ideas for new tenants before deciding to create his own pet project, First Stage Milwaukee Theater for All Ages. As a start-up, the company was a part of the Performing Arts Center with a former Milwaukee Repertory Theater stage manager and director Rob Goodman serving as artistic director. Its first production would be *Sleeping Beauty*, and eventually the company would become a separate entity that continues to produce in the Performing Arts Center officially called First Stage Milwaukee Children's Theater. (Courtesy of First Stage Milwaukee Children's Theater.)

Popular seasonal tales like *The Best Christmas Pageant Ever* (at right) play well in First Stage's Todd Wehr Theater performance home. First Stage Children's Theater developed new works like *A Midnight Cry* (below) in its desire to teach tolerance and the importance of literature in education and entertainment. First Stage casts its plays with a mix of professional adult actors and serious young performers. Young performers must sign agreements with the theater that their education will not be affected by their participation in stage work. There is always a desire to mix real life and stage life in the First Stage approach to theater. (Courtesy of First Stage Milwaukee Children's Theater.)

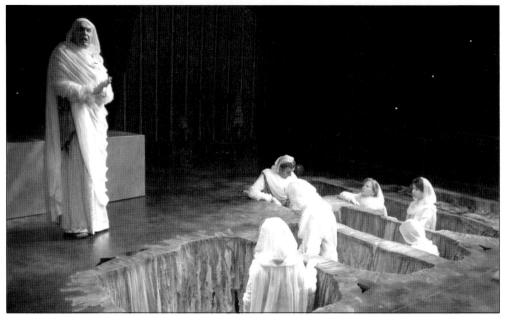

First Stage addresses serious themes with sensitivity as it did in its 2008 production of *Gossamer* (above). Programming can also be superbly fun-loving at First Stage, and audiences delight in the many musical and comic presentations. Productions like *Mouse and the Motorcycle* (below) in 2002 subvert seriousness for a grand celebration of the sillies. First Stage stresses the importance of being able to engage in active play for children and adults alike. Their production values rank among the finest in Milwaukee, and the company is consistently recognized as one of the nation's leading children's theaters. (Courtesy of First Stage Milwaukee Children's Theater.)

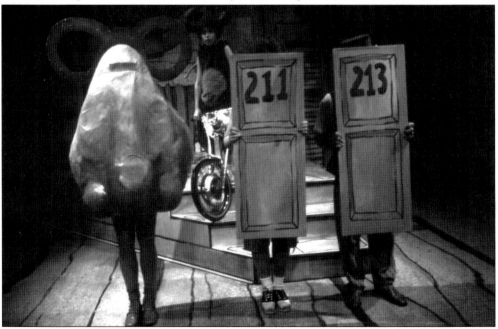

One component of First Stage's artistic agenda is promoting tours of plays to underserved communities. Access to the arts is a key component of the First Stage philosophy. First Stage also believes in a culturally diverse group of artists addressing the needs of audience members throughout the community. Active dialogue between audience and artist is encouraged at all Todd Wehr Theater performances, and that interaction is strongly encouraged when First Stage gets into local communities. Performers conduct talkbacks following all First Stage presentations where audiences have immediate personal access to artists. (Courtesy of First Stage Milwaukee Children's Theater.)

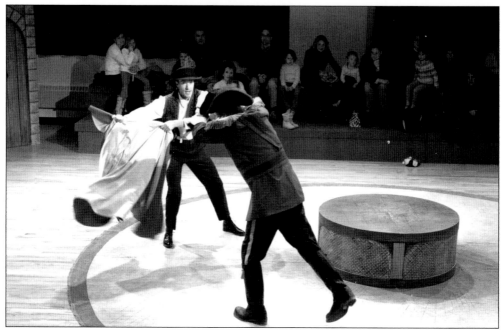

The artistic programming of First Stage Children's Theater is supported in full measure by the First Stage Children's Theater Academy. Classes in all disciplines are taught in a beautiful facility called the Milwaukee Youth Arts Center that is shared with the Milwaukee Youth Symphony Orchestra. The educational philosophy of First Stage Academy translates into teaching students life skills through stage skills. Classes at First Stage Theater Academy range from beginner's acting to on-camera commercial performance. (Courtesy of First Stage Milwaukee Children's Theater.)

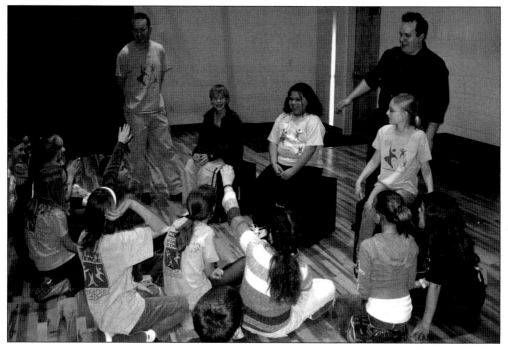

# *Six*

# STIRRING THE POT

Theater movements start when theater artists get itches to move away from the pack. That is what the Milwaukee theater movement was all about in the 1980s. Big institutions like Milwaukee Repertory Theater had become well-run play factories that served mass appeal presentations to a willing audience. In the shadow of that stability, original ideas were percolating. Theater in Milwaukee would take some big steps away from the center in the later years of the 20th century because of radical thinkers who wanted to blaze new dramatic trails.

Montgomery Davis and Ruth Schudson were valuable members of the Milwaukee Repertory Theater acting company in the 1970s when they were both struck with the idea that it was time for Milwaukee audiences to experience theater in its most intimate form. The original manifestation of that idea found Davis and Schudson performing in decidedly intimate circumstances, with the pair doing private "chamber" performances in living rooms around town. Milwaukee Chamber Theater would grow out of these home visits with the troupe quickly establishing itself as a new sort of company with an eye for the literary impact of theater.

Around the same time, Milwaukee theater also went out on the farthest reaches of the cutting edge with the introduction of Theatre X. Theatre X was dedicated to the experimental exploration of theater. Its physically charged, emotionally jarring productions for Milwaukee audiences and those who were introduced to Theatre X during their frequent tours of Europe and the United States are the stuff of legend.

The vast difference in the literary programming of Milwaukee Chamber Theater and the experimental nature of Theatre X provided opportunities for other emerging producers to capitalize on audience desires for even more engaging, small-scale programming. Clavis Theater, Theatre Tesseract, and then Next Act Theatre helped introduce the off-Broadway style of theater to Milwaukee audiences. The need to explore different stories by a thriving pool of local talent generated great theatrical heat in the 1980s and 1990s and made Milwaukee a town where it seemed there was a theater on every corner.

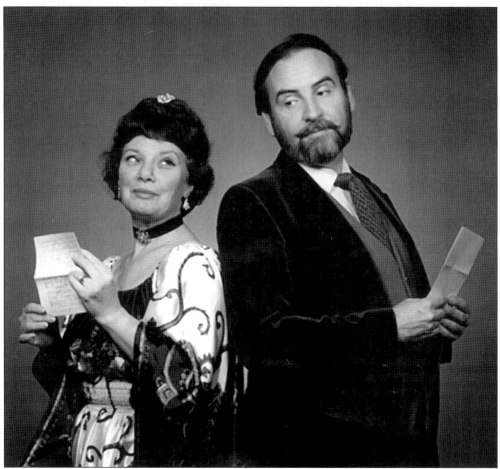

Milwaukee Chamber Theatre cofounders Ruth Schudson and Montgomery Davis were often paired together onstage because of their winning chemistry. Here they are pictured in a scene from George Bernard Shaw's *Dear Liar*. Milwaukee Chamber Theatre promoted the works of Shaw unlike other groups in the nation with its yearly presentation of a Shaw Festival during the artistic directorship of Montgomery Davis. Until his untimely death from complications brought on by a sudden stroke in 2007, Davis was regarded locally and nationally as something of a "Shavian character," a fan of George Bernard Shaw to the highest degree. (Courtesy of Milwaukee Chamber Theatre.)

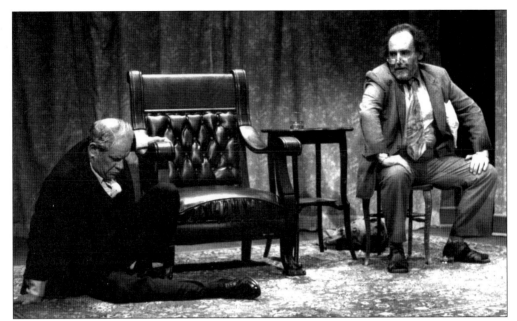

Durward "Dewey" McDonald and Montgomery Davis performed in Harold Pinter's *No Man's Land* for Milwaukee Chamber Theatre in 1989. Milwaukee Chamber Theatre distinguished itself as "the thinking man's theater company" with artistic director Davis's play selection favoring words over actions. The two old actor friends were more than happy to battle each other nightly using Harold Pinter's language. (Courtesy of Milwaukee Chamber Theatre.)

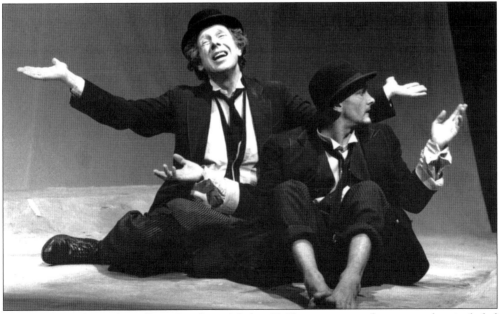

*Waiting for Godot* with William Leach and James DeVita was part of a season that included T. S. Eliot's *Murder in the Cathedral* and George Bernard Shaw's *The Admirable Bashville*. It was not always easy for Milwaukee Chamber Theatre to be Milwaukee's book-smart theater. One Milwaukee Chamber Theatre supporter offered to donate a large sum of cash if the annual money-losing Shaw Festival would quietly disappear. (Courtesy of Milwaukee Chamber Theatre.)

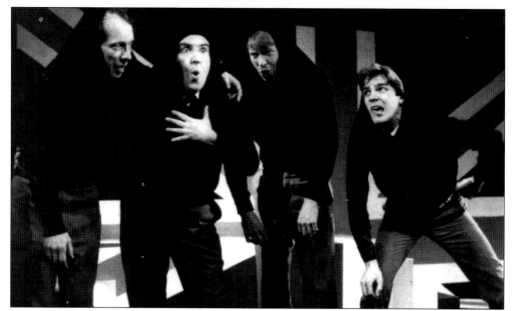

Milwaukee Chamber Theatre could be seriously silly and British with productions like *On the Fringe* (above) or goofily nostalgic with the quaint comedy *Clarence*, a star vehicle for Alfred Lunt when it was introduced in 1921. Through some theatrical magic, Helen Hayes, the ingenue of the original 1921 production, visited Milwaukee Chamber Theatre's *Clarence* company. Montgomery Davis was never afraid to write a letter to a star hoping to make some theatrical-dream-come-true union a reality for his hardworking and underpaid actors. (Courtesy of Milwaukee Chamber Theatre.)

Milwaukee Chamber Theatre performed in a number of different spaces in the 1980s. It shared the stage with the Skylight Opera Theatre at Skylight's charming sightline-challenged Jefferson Street location. Many of its shows were performed in the Stiemke Theater at Milwaukee Repertory Theater's downtown theater complex. Milwaukee Chamber Theatre had a gypsy existence for shows like *Heartbreak House* (at right) and *Frankie and Johnny in the Claire de Lune* (below), which starred Milwaukee native Anthony Crivello prior to his Tony Award win for *Kiss of the Spiderwoman*. When Milwaukee Chamber Theatre became a part of the triumvirate that was also made up of Skylight Opera Theatre and Theatre X that helped make the Broadway Theatre Center project a reality, space searches seemed to be a thing of the past. (Courtesy of Milwaukee Chamber Theatre.)

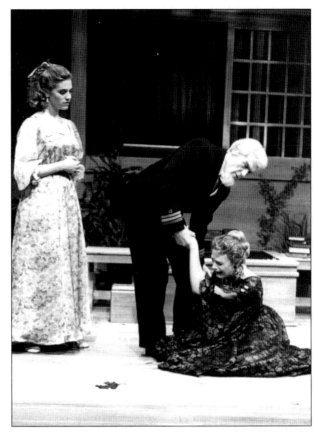

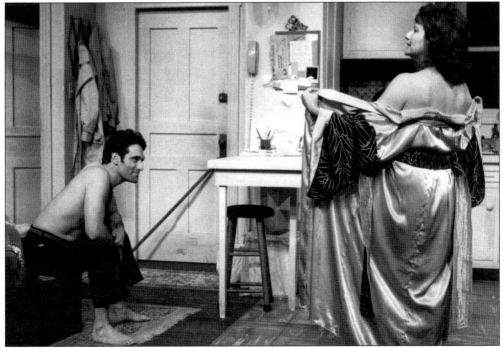

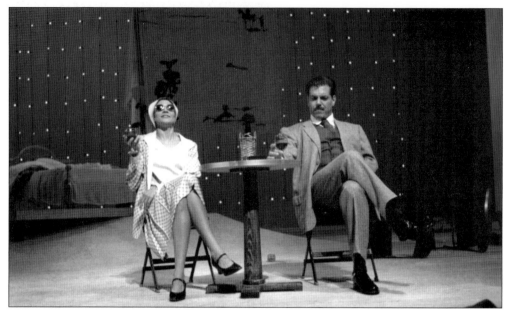

Residency in the Broadway Theatre Center allowed Milwaukee Chamber Theatre to work on and develop new works such as a stage version of *The Sun Also Rises* by local playwright and alderman Wayne Frank. Hemingway's original literary gem received special attention from a company that had built its reputation on a commitment to literature-based theater. But residency in the Broadway Theatre Center also challenged Milwaukee Chamber Theatre to fill more seats. The year after the last production of George Bernard Shaw would grace a Milwaukee Chamber Theatre in a track of consecutive seasons, programming had shifted to plays like the ultra-contemporary *Take Me Out*. Milwaukee Chamber Theatre was looking for support from the same younger audiences that other theaters were and had to shift its focus to keep up with the pack. (Courtesy of Milwaukee Chamber Theatre.)

One of the biggest indications that Milwaukee Chamber Theatre had been forced by circumstance in the late 1990s and early 2000s to capture a new audience was the choice to produce the rock musical *Hedwig and the Angry Inch* (at right). The same patrons who had flocked to Milwaukee Chamber Theatre for delicate plays by Christopher Fry and Athol Fugard were now swinging their hips to a transvesite rock-and-roll singer. The man with the biggest smile over that coup de theatre was himself, the forever droll heart of the organization, Montgomery Davis (below). With his death in 2007, a new era of Milwaukee Chamber Theatre arrived guided by the company's new artistic director, C. Michael Wright. (Courtesy of Milwaukee Chamber Theatre.)

Ben Hobbler and Sharon McQueen appeared in Clavis Theatre's production of *Beyond Therapy* in 1983. *Beyond Therapy* described Sharon McQueen's ups and downs as a take-chances producer in the 1980s. Clavis was the combination of McQueen's grandmothers' names. A bitter dispute with her cofounder prompted her to create Theatre Tesseract, a successful company based on the edgy, off-Broadway-style experience audiences seemed to crave. (Courtesy of University of Wisconsin-Milwaukee Archives.)

David Cecsarini, pictured here in a publicity photograph for Theatere Tesseract's 1988–1989 theater season production of *Billy Bishop Goes to War*, is one of the Milwaukee actors who fall into the actor/manager category. Cecsarini would go on to lead Next Act Theatre in the wake of Theatre Tesseract's breakup due to financial and internal problems. (Courtesy of Next Act Theatre.)

Milwaukee theater artists have a love affair with the stage that often translates into serious offstage romance. Laura Gordon and Jonathan Smoots, pictured in Next Act Theatre's 1991 production of *And a Nightingale Sang*, are one of the many married theater couples who have decided to make Milwaukee their home base. (Courtesy of Next Act Theatre.)

C. Michael Wright and Lewan Alexander performed in Next Act Theatre's popular production of *The Boys Next Door*. Wright also became Milwaukee Chamber Theatre's producing artistic director in 2006. Alexander was a student in the University of Wisconsin-Milwaukee's PTTP. The actors were not Wisconsin natives, but local audiences would come to know them both from their countless stage appearances. (Courtesy of Next Act Theatre.)

Milwaukee theater artists are not beyond giving a nod to Milwaukee patrons' mania for all things sports. This photograph from Next Act Theatre's production of *Cobb*, a play about baseball legend Ty Cobb, features Ted Sorce as the "Georgia Peach." (Courtesy of Next Act Theatre.)

Next Act Theatre was a transient theater for a great part of its production history. When it converted a second-story office space in Milwaukee's Third Ward into the 99-seat Off Broadway Theatre, Next Act became a company known for telling socially responsible and entertaining stories. Paul Mabon appeared in Next Act's original 2007 production of *Robeson*, an engrossing retelling of Paul Robeson's life. (Courtesy of Next Act Theatre.)

Men in dresses and men in locker rooms is a quick look at the Next Act Theatre of the modern era. The pure joy of *The Mystery of Irma Vep* (above) and the testosterone rush of *Lombardi: One Thing More* (below) is typical of a Next Act Theatre season of plays. Whimsy and wonder define the Next Act Theatre's up-close-and-personal performance style. (Courtesy of Next Act Theatre.)

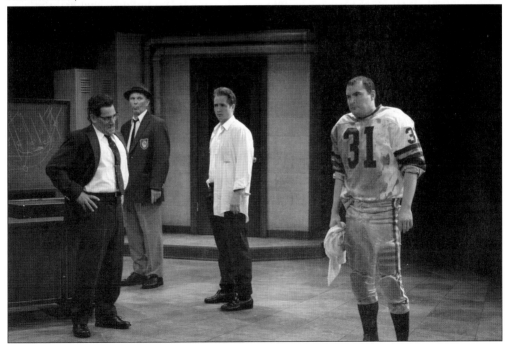

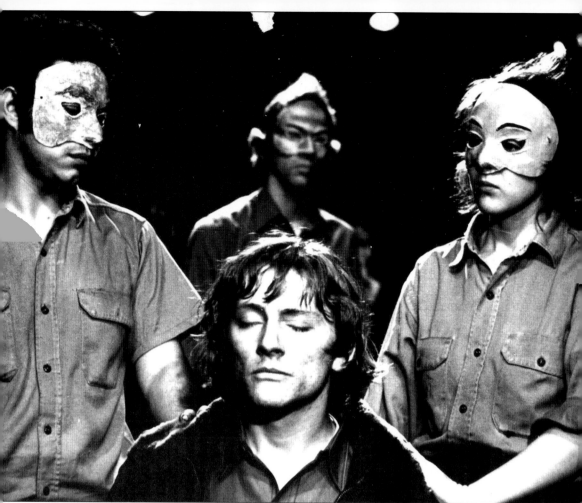

Tom Gustin is surrounded by masked players in Theatre X's 1970 production of *The Measure's Taken*. After its formation in 1969, Theatre X literally burst onto the national scene with this newly adapted Eric Bentley version of Bertolt Brecht's play. It was presented at the First International Brecht Symposium at University of Wisconsin-Milwaukee, and scholars and theater enthusiasts from around the globe immediately saw that Theatre X was doing something new, inventive, and different. It was producing theater on its own terms in an experimental way that recognized a kind of self-conscious regard for how theater can effect people. Theatre X was created as a kind of test case, an experimental theater company for Milwaukee that gave all its company members an equal voice in the creation of the troupe's work. That structure proved hard to maintain 30 years after its thrilling start, and the troupe was forced to disband in 2003, but in the intervening years Theatre X was for a time the most well-known theater company from Milwaukee on the world stage. (Courtesy of John Schneider.)

Theatre X's first official production in 1969 was an original creation called X *Communication*. The revue was a collection of short response pieces to events of the time on the minds of the Theatre X company members. Conrad and Linda Bishop led the troupe through these formative years. X *Communication* would remain a part of Theatre X's repertoire of regularly performed plays until 1974. (Courtesy of John Schneider.)

Tom Gustin was one of Theatre X's most active early company members and starred in John Schneider's play *A Fierce Longing* in the late 1970s. *A Fierce Longing* would be performed off-Broadway in 1978 at New York's Performing Garage. That production would go on to win an Obie Award, off Broadway's most revered award, for production design. (Courtesy of John Schneider.)

The snarl, the lean forward, the slight flash of danger in the eyes: that was the picture of Theatre X. John Schneider (at left) became the primary torchbearer of this attitude in his role as playwright and artistic director. The Theatre X collective was whittled to its essence as Schneider and company members Flora Coker, Deborah Clifton, John Kishline, and Marci Hoffman. They would define the Theatre X spirit for Milwaukee audiences well into the early 2000s. Other members like movie star Willem Dafoe and Sharon Ott (singing in this 1979 photograph of *Schmaltz*), who would become a leader of several regional theaters after her time at Theatre X, would come and go, but the core remained believing in a style of theater that tested audience sensibilities time and again. (Courtesy of John Schneider.)

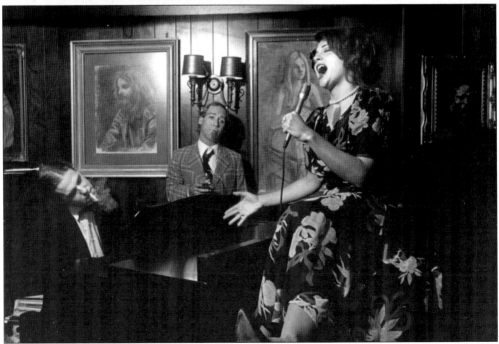

Theatre X plays like *The History of Sexuality* were recognized by critics as towering achievements. Theatre X would tour these pieces around the world, most notably in continual residences at the Mickery Theater in Amsterdam. The reality of Theatre X's fate as a Milwaukee theater company was that it was better known around the world than it was in Milwaukee through the 1970s and 1980s. Theatre X stayed true to its mission of creating experimental work even in the toughest of times. (Courtesy of John Schneider.)

Theatre X maintained a healthy artistic forum for its acting company with the introduction of new directors and new players. Theatre X company member John Kishline and local actor Chris Flieller appeared in C. P. Taylor's gripping World War II play *Good*, directed by J. R. Sullivan. The infusion of new voices and ideas brought renewed energy to the company in the years leading up to its disbanding. (Courtesy of Chris Flieller.)

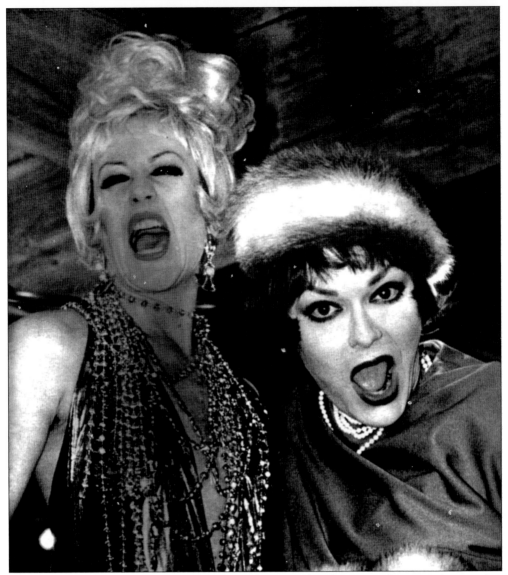

Theatre X "took back the night" when it tackled Late Night Theater productions of campy fare such as *Vampire Lesbians of Sodom* with B. J. Daniels and Elaine Wyler. These types of events were meant to light fires under "the bar crowd" as theater companies in Milwaukee in the late 1990s and early 2000s battled the war over capturing entertainment dollars in an increasingly stuffed cultural landscape that also had to compete with distractions from television, the movies, and the Internet. Young performers and audiences flocked to the late-night theater scene as an alternative to smoky bars and overamplified rock concerts. (Courtesy of J. T. West.)

# Seven

# An Embarrassment
# of Riches

In 1842, Milwaukee audiences saw a performance of *The Merchant of Venice* that kicked off a grand tradition of theatergoing in the community. By 2003, when Milwaukee Shakespeare presented a wildly interpreted production of *The Merchant of Venice* employing state-of-the-art video integration into the live stage presentation, Milwaukee theater had become a year-round affair. Theater in Milwaukee was no longer a special event. It was "the event."

The confluence of great theater training paired with a local commitment to embracing a forever-growing pool of talent made it possible by the dawn of the 20th century that Milwaukee theater could stand alongside any theater movement worldwide and be judged as an astounding achievement forged from an extraordinary history of respect for the art and artist.

On almost any given night in Milwaukee, audiences can catch a new interpretation of a classic work, one of Broadway's recent hits, or a long-forgotten literary gem newly discovered by the fresh eyes of young theater artists wanting to make their voice heard in the busy Milwaukee cultural landscape. Theaters run by rapscallions, theaters run by women, theaters run by people of color, and theaters run by gay and lesbian artists make up the whole of what has become the thriving Milwaukee theater scene.

Theater in Milwaukee only gets better as time goes on, because audiences demand it should. After 150 years of watching theater, Milwaukee audiences know what they want. They want passion conveyed through the actions and words of a group of hardworking men and women who live and work in the community. No matter where it is happening, Milwaukee theater is happening with an eye to the future that demands more ideas, more creativity, and more community connections.

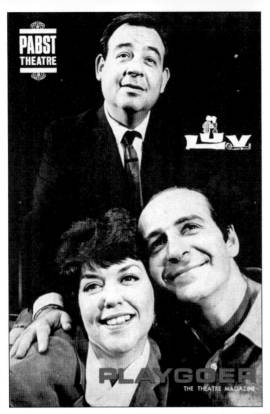

Tours still hit Milwaukee after the heyday of the 1930s and the 1940s, but the charged experience of seeing something special in the theater was not the same as it had been when Alfred Lunt and Lynn Fontanne and others were regularly touring. A production of Murray Schisgal's *Luv* with Tom Bosley did not set box office records at the Pabst Theater. The Palace Theater saw its own stop through production of the 1960s love-in musical *Hair* that the patron who original clutched the shown program evaluated as "Horrible." Milwaukee audiences were spoiled with the great successes of local theater that had flowered since the advent of the Fred Miller Theatre. (Courtesy of Milwaukee Repertory Theater.)

# PLAYBILL

*Milwaukee's magazine for theatregoers*

*Horrible*

# HAÏR.

The American Tribal-Love Rock Musical

**PALACE THEATRE**
January 12 - 31, 1971
Marcus Productions, Inc.

Center Stage was a flash in the pan commercial failure in downtown Milwaukee. Gypsy Rose Lee opened the downtown theater, and stars like Ellen Terry, best known for singing the kitsch song "If I Knew You Were Coming I'd Have Baked a Cake," were the headliners. The quality of shows was subpar at best, and the audience responded with a lack of adequate ticket purchases. A similar fate would ultimately sink Milwaukee Inside Theater, which became Waukesha County's American Inside Theater. That company tried to spearhead an effort to restore Ten Chimneys that did not materialize until a private foundation took over. American Inside Theater produced Neil Simon's *Lost in Yonkers* with John Randolph (second from left) and Jane Kazmaryck (right) at the Pabst Theater in the early 1990s. (At right, courtesy of Michael Neville; below, courtesy of Norman Moses.)

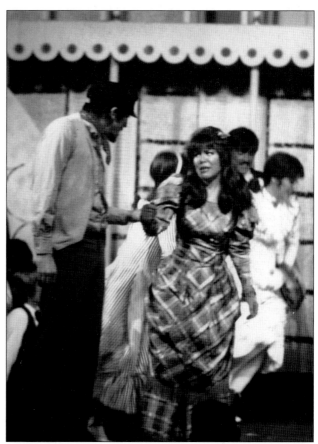

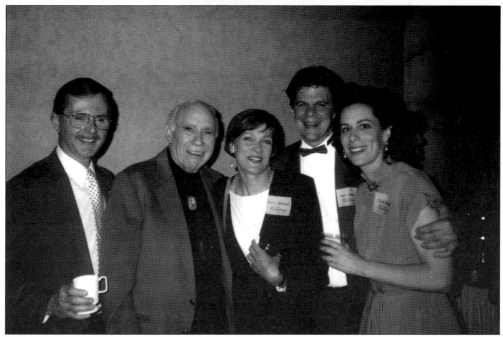

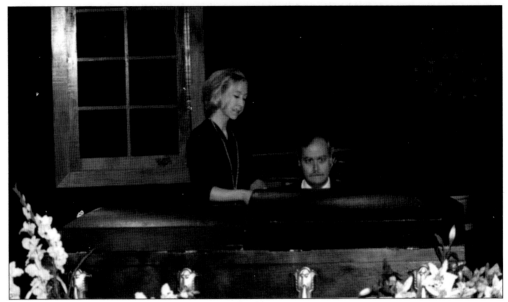

Amethyst Productions was primarily known in the late 1990s for producing outdoor productions of Shakespeare at Villa Terrace Decorative Arts Museum. This production of Joe Orton's *Loot* was presented at the Broadway Theatre Center Studio Theater, however. The producers of Amethyst Productions eventually owned the old Fred Miller Theatre for some time, renaming it the Miramar and booking it with concerts, wrestling matches, and church services. (Courtesy of J. T. West.)

Funnyman John McGivern seemed to have the touch of gold when he started producing his own one-man shows about growing up Catholic and gay in Milwaukee during the 1960s. McGivern made his triumphant return to Milwaukee theater in the early 2000s with a record-breaking box office stunner called *Shear Madness*, produced in partnership with Milwaukee Repertory Theater. (Courtesy of John McGivern.)

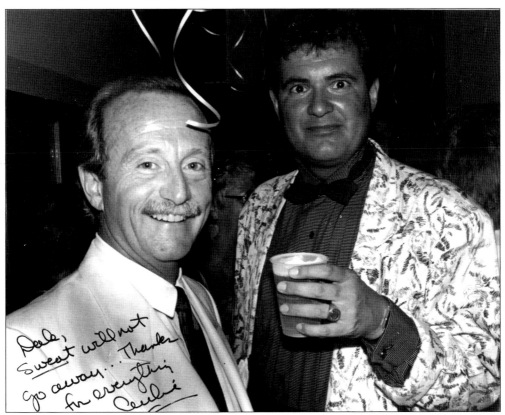

Dale Gutzman is a Milwaukee theater fixture. He was an acolyte of Clair Richardson and Robert Pitman and served as director of the Milwaukee Players for several years until that organization was forced to close when Milwaukee County government budgets deemed the arts program unaffordable in the late 1990s. Gutzman produced variety shows and fully staged productions for Archie Sarazin at the Performing Arts Center in the 1970s and 1980s (above). For over 20 years, his yearly production of the satiric Christmas show *Holiday Punch* has delighted audiences. Off the Wall Theater is a small converted retail space across the street from the Milwaukee Repertory Theater where Gutzman started producing plays and musicals in 2000. (Courtesy of Dale Gutzman.)

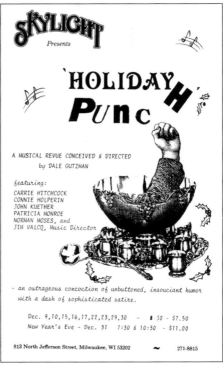

**SKYLIGHT** Presents

**'HOLIDAY PUNCH'**

A MUSICAL REVUE CONCEIVED & DIRECTED by DALE GUTZMAN

featuring:
CARRIE HITCHCOCK
CONNIE HOLPERIN
JOHN KUETHER
PATRICIA MONROE
NORMAN MOSES, and
JIM VALCQ, Music Director

- an outrageous concoction of unbuttoned, insouciant humor with a dash of sophisticated satire.

Dec. 9,10,15,16,17,22,23,29,30 - 8 30 - $7.50
New Year's Eve - Dec. 31   7:30 & 10:30 - $11.00

813 North Jefferson Street, Milwaukee, WI 53202   ~   271-8815

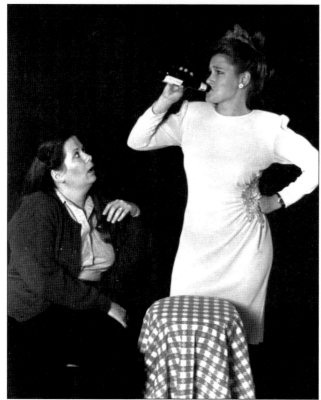

Michelle Traband, Jennifer Rupp, Susan Fete, Raeleen McMillion, and Marie Kohler had more than coffee one day sitting around a kitchen table in 1993. They had the idea to start Renaissance Theaterworks, Milwaukee's only company focusing on the exploration of a female voice for the theater. *Imagining Brad* with Carol Johnson and Raeleen McMillion was their first production (at left), and they soon started to pique the interest of serious theatergoers around town. Their popular revue called *Red Pepper Jelly* (below) has played in three different versions to enthusiastic crowds eager to hear more of the women's fun and revealing personal stories. (Courtesy of Renaissance Theaterworks.)

It is wrong to assume that Milwaukee's only theater dedicated to promoting a female voice just does plays for and about women. Promoting the female theater voice has meant producing Suzan Lori-Parks's 2002 Pulitzer Prize–winning play *Topdog/Underdog* (above). It can also mean chilling audiences with Stephen Mallatratt's adaptation of Susan Hill's novel *The Woman in Black*. Renaissance Theaterworks does not define its working methodology down gender lines. The women who created the group still contribute as producers and stage directors, but their outlook on producing theater includes the entire community. Since 2004, Renaissance Theaterworks has been a resident company of the Broadway Theater Center. (Courtesy of Renaissance Theaterworks.)

James DeVita and Mary MacDonald Kerr starred in Renaissance Theaterworks' 2006 production of *Burn This*. The production marked DeVita's return to performing in Milwaukee after a 15-year absence brought upon by his work with Spring Green's American Players Theater. The combination of DeVita and Milwaukee favorite MacDonald Kerr created a heat that audiences fell over themselves to bask in during this box office smash. (Courtesy of Renaissance Theaterworks.)

Performers at the Broadway Baby Dinner Theater delighted audiences in this scene from *Midlife Crisis—The Musical*. The company specialized in sprightly reviews, sex farces, old-time Broadway musicals, and creamy rich cheesecake. Elaine Parsons and John Bohan were the dynamic duo behind this one-of-a-kind venture, but the lady of the house took care of the desserts all alone. (Courtesy of Elaine Parsons-Herro.)

Tom Shimmel, Michael Neville, Chris Fleiller, and Ted Tyson (from left to right) are seen contemplating Shakespeare in one of Playwrights Studio Theatre's Ten-Minute Play Festivals in the early 1990s. Playwrights Studio Theatre was founded by Milwaukee native Michael Neville to produce new plays by emerging playwrights. (Courtesy of Playwrights Studio Theatre.)

Neville's Playwrights Studio Theatre produced new plays by dozens of playwrights during the 1990s and early 2000s. This image of Norman Moses is from Neville's own *Lamps for My Family. Lamps for My Family* was developed over several years based on collected tales from the playwright's own Irish family. (Courtesy of Playwrights Studio Theatre.)

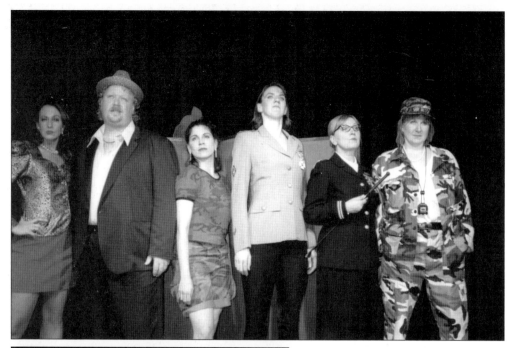

During the 1990s, Playwrights Studio Theatre was a superb company for emerging talent to have chances to dig into new work. Plays ranged from the campy late-night theater piece *School Girls in Uniform* (above) to the two-hander *Dracula vs. the Nazis* starring Michael Neville and Chris Fleiller. Playwright and founder Michael Neville was the most produced playwright of the troupe, with a range of subjects that shuttled between ridiculous fun and thoughtful explorations of modern themes. The company's new play-reading series in the 1990s was also a popular way for actors and audiences to connect with theater in doses that did not require large commitments of time. (Courtesy of Michael Neville.)

The Ten-Minute Play Festival brought together a huge pool of Milwaukee talent who started to make company-to-company connections that helped a great cross-pollination of ideas to flourish among smaller groups. The Ten Minute Play Festival made a return to Milwaukee in 2007 after several years' hiatus and proved again that Milwaukee actors are serious about presenting new work. (Courtesy of Playwrights Studio Theatre.)

Scott Howland and Stephen Roselin starred in Bialystock and Bloom's 1995 production of *Bent*. The two actors were also cofounders of the group that ultimately would be referred to with love by fans and the press as "the bad boys" of Milwaukee theater. The Bialystock and Bloom production about gay persecution in the Holocaust had everything going against it. The two actors and the rest of the 14-member cast were offered promises of drink purchases at the local bar instead of salaries. The two-hour-long drama was also presented for audiences at 11:00 p.m. on top of the set for another theater performing at "prime time." Audience response was extraordinary, and the group went on to present plays for the next 11 years. (Courtesy of Bialystock and Bloom.)

Productions like *Killer Joe* (above) with John Maclay and Jeremy Woods shocked and stunned Milwaukee audiences looking for a thrill ride. Sex, nudity, violence, and incest were among the taboo subjects Bialystock and Bloom was never afraid to tackle. It was so noted for doing productions that featured nudity that infamous Milwaukee nudist Dick Bacon was a regular fan until his death. The company had a reputation for taking great risks while still creating a fun atmosphere for both audiences and actors alike. Its productions could also make audiences weep, as they did with the sorrow-filled ending to *The House of Blue Leaves* (at right). (Courtesy of Bialystock and Bloom.)

By the time it had produced its last production in 2006, Bialystock and Bloom had gone from being an itinerant theater performing in small theaters around Milwaukee to a resident force in the Broadway Theater Center. Its edge-treading work was innovative on every level. A production of Israel Horowitz's *The Widow's Blind* (above) was performed in a barbed wire cage. *Bat Boy, the Musical!* (below) was a summer hit for Bialystock and Bloom in 2003. Audiences enjoyed the easy open environment that Bialystock and Bloom cultivated for its audiences. For several years, the company had an official beer sponsor and audiences benefited from the generosity of local brewers with free suds at Bialystock and Bloom performances. (Courtesy of Bialystock and Bloom.)

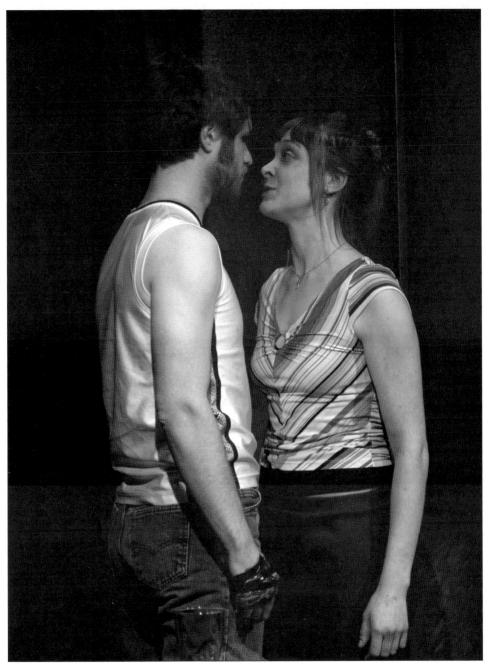

Marcus Trucshinski and Sarah Sokolovic battled each other nightly in Bialystock and Bloom's sizzling 2005 production of *Danny and the Deep Blue Sea*. Like many other companies before it, the small-sized Bialystock and Bloom decided to cease production in 2006 because of mounting financial concerns. Before bowing out, Bialystock and Bloom presented one final show featuring many of the performers from Bialystock and Bloom's 11-year run. The cofounders had started the company as a tribute to the producing team of Bialystock and Bloom in Mel Brooks's film *The Producers* and kept a sense of humor alive in everything they did up until the end of their time in Milwaukee. (Courtesy of Bialystock and Bloom.)

When it comes to storefront theaters, Milwaukee's Boulevard Ensemble Studio Theater is the textbook definition of a success story. Boulevard Ensemble began its life in a Riverwest coffee shop in the early 1980s. A move to Bay View to rent a building that had at one time been a dirty book shop proved to be the key to Boulevard's unique place in the community. The small performance space boasted only about 40 seats when it opened, and remodeling over the years only boosted the capacity slightly higher. The Boulevard bought the building that houses its theater in 2000 after years and years of renting the space. Mark Bucher, its founder, has led the effort to welcome amateur actors into the Boulevard family for over 20 years. (Courtesy of Boulevard Ensmble Studio Theater.)

Mission means many things when applied to theater companies. In the case of Acacia Theatre Company, mission has purposeful Christian overtones. Acacia Theatre is Milwaukee's only Christian theater company, and its programming reflects that commitment. Its work can be overtly based in Christian themes or more delicately balanced for presentations that appeal to secular audiences such as its production of *The Women of Lockerbie*. Performers are all volunteers and agree to Acacia's practice of prayer before rehearsals and performances because they feel it is part and parcel of their theatrical and life calling. (Courtesy of J. Fassl, AntiShadows.)

Losers (above) was the name of the first full-length play produced by Bunny Gumbo theater company in 2007. Losers featured several actors who were popular with Milwaukee audiences because of their work with Bunny Gumbo's signature presentation, Combat Theater. Mic Mataresse, Amy Geyser, and Bunny Gumbo artistic director and cofounder James Fletcher are seen in this Combat Theater mounting of Little Sally Simpson and All The Hard to Reach Places. The script was written after the playwright chose an idea from a hat. The fully written play was then submitted after one night of writing and presented fully staged by a group of actors 24 hours from conception. These wildly popular nights of skits and short plays are audience favorites that Bunny Gumbo manages to produce twice a year. (Courtesy of Bunny Gumbo.)

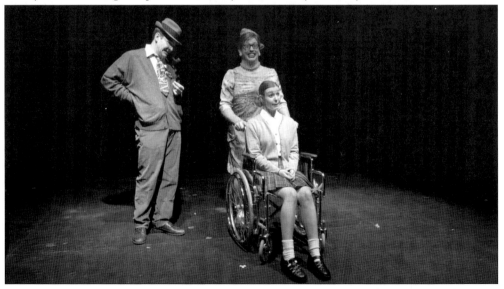

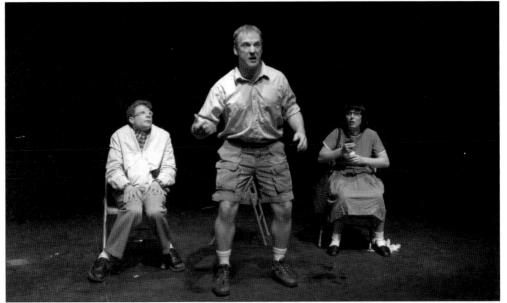

Facile Milwaukee actors like Stephan Roselin, Lee Becker (center), and Bridget Hicks are the reason Bunny Gumbo has succeeded. With little rehearsal time, actors must create quick characters that audiences remember. This Crocodile Hunter spoof was a winner that went from page to stage in less than a day. (Courtesy of Bunny Gumbo.)

When a small theater finally finds a home to produce plays, it is a cause for celebration. That was why In Tandem Theater jumped for joy when it moved into the Tenth Street Theater, located in the basement of a downtown Milwaukee church. In Tandem transformed the bare-bones space with help from many members of the welcome acting community providing volunteer labor. (Courtesy of In Tandem Theater.)

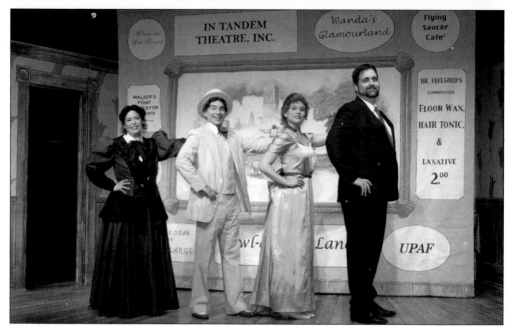

In Tandem's motto suggests that everyone is in the business of creating great art together. That belief was born from founders Chris and Jane Flieller, who developed their ideas of how theater should run into a company structure. In Tandem presented plays like *Cox and Box* (above) as a part of Milwaukee Chamber Theatre's Shaw Shorts element of its annual Shaw Festival for several years. Works like *The Afghan Women*, a play that playwright William Mastrosimone released to In Tandem and only a handful of other American theaters, established its serious presence in the community. (Courtesy of In Tandem Theater.)

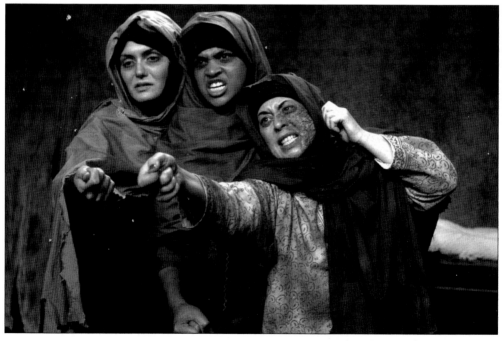

In Tandem Theater's most successful production is the Milwaukee holiday hit *A Cudahy Caroler Christmas*. In Tandem cofounder Chris Flieller puts all his training as a former student in University of Wisconsin-Milwaukee's esteemed PTTP to the test as a south side Milwaukee caroler looking to make it big. (Courtesy of In Tandem Theater.)

Friends Mime Theatre started a worthy mission in 1973. Their goal was to bring theater to people wherever they gathered. Most of the time they wanted to do it for free. And they also wanted to introduce folks to music, art, and dance. While they changed their name to Milwaukee Public Theatre since they first started their outreach-driven company, their purpose has never changed. (Courtesy of Milwaukee Public Theatre.)

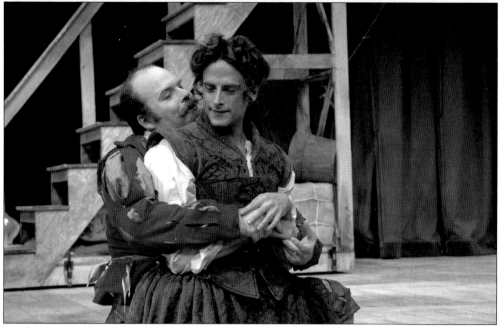

By the time Milwaukee Shakespeare had presented its all-male production of *The Taming of the Shrew*, starring Matt Daniels as Petruchio and Michael Gotch as Kate, it had left an indelible mark on Milwaukee audiences. Audiences agreed that a world-class theater city should support a world-class Shakespeare company. (Photograph by Lila Aryan, courtesy of Milwaukee Shakespeare.)

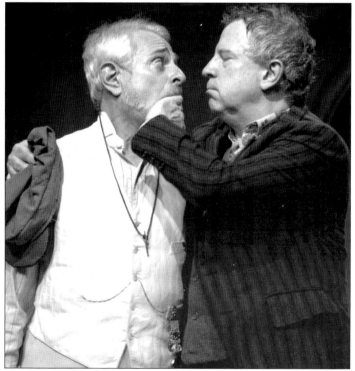

Veteran actors Robert Spencer and Ross Lehman made audiences laugh in Milwaukee Shakespeare's 2006 production of *Much Ado About Nothing*. Milwaukee Shakespeare began production in the 99-seat Off Broadway Theater as a rental company in 2000 with a muscular production of *Macbeth*. The company was founded by Lawrence University graduates Chris Abele and John Maclay out of burning love for the bard. (Photograph by Lila Aryan, courtesy of Milwaukee Shakespeare.)

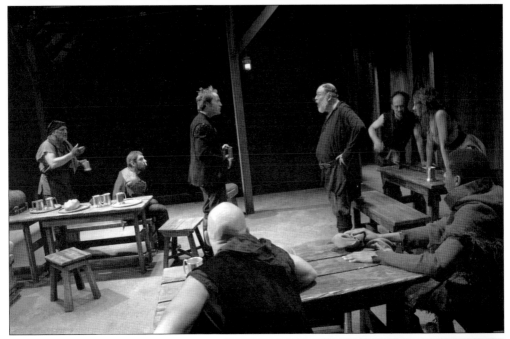

Milwaukee Shakespeare proved to Milwaukee audiences that Shakespeare is not stuffy scholarly fare. Its pulsing productions often played in small spaces such as its 2007 production of *1 Henry IV* in the 99-seat Broadway Theater Center Studio Theater (above). It also performed works with a special twist and vision that brings Shakespeare's work to life for modern audiences such as its 2008 production of *Twelfth Night*. Education was a huge part of Milwaukee Shakespeare's mission and it was a multiple-year recipient of National Endowment for the Arts funding, recognizing its successful outreach programming and reduced-fee ticket plans for area schools. (Photographs by Lila Aryan, courtesy of Milwaukee Shakespeare.)

Performers Kevin Rich and Victoria Caciopoli were one of the romantic pairs in Milwaukee Shakespeare's updated 2008 production of *Love's Labours Lost*, which proved to be its last. A sudden loss of funding due to the stock market turmoil of 2008 brought an abrupt end to this respected classical company. The production set the action of the play as a reality television show. (Photograph by Lila Aryan, courtesy of Milwaukee Shakespeare.)

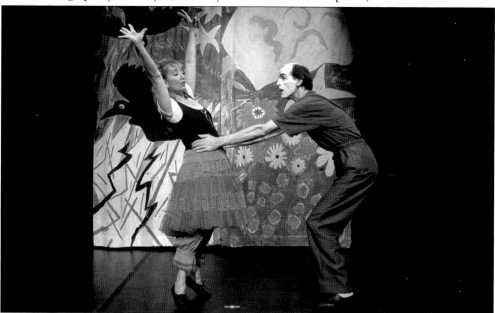

Theatre Gigante is a big name for a small theater with huge ideas. Theatre Gigante started its life as Milwaukee Dance Theatre in 1987. The name change came about in 2006 when the company realized it needed a new name to reflect its stronger focus on theater over dance. Here coartistic directors Isabelle Kralj and Mark Anderson perform their lively production of *Petruska*. (Courtesy of Theatre Gigante.)

Although Theatre Gigante does concentrate more heavily in its current form on telling stories using a theatrical vocabulary, movement and dance are still a large part of its performance style. Its production of *Everyman* used actors in masks and stretched the boundaries of how theater can be presented with a physical presentation that rivaled many modern dance troupes. (Courtesy of Theatre Gigante.)

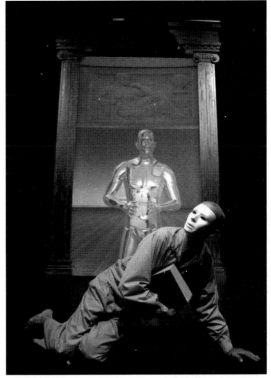

The fans of Windfall Theatre Company owe Milwaukee Repertory Theater a debt of gratitude. The small company was formed by a group of former Milwaukee Repertory Theater interns who found a supportive environment to perform in downtown Milwaukee's Village Church. Their performances introduce Milwaukee audiences to little-seen works by important modern theater voices. (Courtesy of Windfall Theatre Company.)

Windfall Theatre Company has a rich love of musical theater and has been able to pull off some stunning hat tricks in producing big cast musicals in its intimate church hall performance home. A production of *The Baker's Wife* showcased invention and creativity over splashy production. Its casts of semiprofessional actors also work on new work that is frequently generated from within company ranks. (Courtesy of Windfall Theatre Company.)

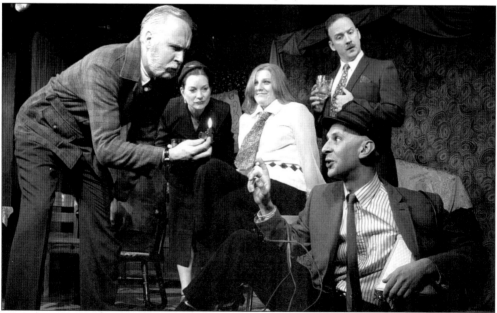

Milwaukee theater companies perform in the tiniest of spaces. Cornerstone Theatre Company had an engaging performance history in the basement of the Brumder Mansion, a bed-and-breakfast just west of downtown Milwaukee. Its cramped performance space helped rather than hindered Cornerstone to perform inventive productions such as the comic *Black Comedy* during the early 2000s. (Courtesy of Patrick Holland.)

The future of Milwaukee's next theater wave can be found in the energy and enthusiasm of Milwaukee's do-it-yourself theater companies. Insurgent Theatre (above) and its wild productions that often resemble punk rock concerts more than theater presentations are indicative of the pioneering and adventurous spirit of young groups like Pink Banana Theatre Company, Soulstice Theatre, and Spiral Theatre. Many of these groups utilize the performance space and lounge the Alchemist Theater, which when opened in 2007 became a small theater mecca for young artists wanting to stake their claim in Milwaukee's live theater scene. (Above, courtesy of Insurgent Theatre; below, courtesy of Alchemist Theater.)

# Across America, People are Discovering Something Wonderful. Their Heritage.

Arcadia Publishing is the leading local history publisher in the United States. With more than 3,000 titles in print and hundreds of new titles released every year, Arcadia has extensive specialized experience chronicling the history of communities and celebrating America's hidden stories, bringing to life the people, places, and events from the past. To discover the history of other communities across the nation, please visit:

## www.arcadiapublishing.com

Customized search tools allow you to find regional history books about the town where you grew up, the cities where your friends and family live, the town where your parents met, or even that retirement spot you've been dreaming about.